Simon Patterson
High Noon

IKON

ARTS COUNCIL ENGLAND

Birmingham City Council

THE ELEPHANT TRUST

THE FOYLE FOUNDATION

The Henry Moore Foundation

Scottish Arts Council

Scottish Arts Council LOTTERY FUNDED

Published by:

The Fruitmarket Gallery
45 Market Street,
Edinburgh, EH1 1DF
t: +44 (0) 131 225 2383
f: +44 (0) 131 220 3130
http://www.fruitmarket.co.uk
Registered Scottish charity
no: SC005576

Ikon Gallery
1 Oozells Square,
Brindleyplace,
Birmingham, B1 2HS
t: +44 (0) 121 248 0708
f: +44 (0) 121 248 0709
http://www.ikon-gallery.co.uk
Registered charity no:
528892

Distributed by Art Data
12 Bell Industrial Estate
50 Cunnington Street
London, W4 5HB
t: +44 (0) 208 747 1061
f: +44 (0) 208 742 2319

Edited by Fiona Bradley
and Nigel Prince
Designed by Stephen Coates
Production managed by
Elizabeth McLean
Printed in the UK by
BAS Printers in an edition
of 2,000

ISBN 0 947912 88 6

The Fruitmarket Gallery is
supported by the Scottish
Arts Council.

Ikon gratefully acknowledges
financial assistance from
Arts Council England,
West Midlands and
Birmingham City Council.

With thanks to: Michael
Archer, Nick Barley, Patricia
Bickers, Steven Kirby, Sharon
Summers and Lee Thornton,
Soho Images, London

Published on the occasion
of two complementary and
overlapping exhibitions of
the work of Simon Patterson,
curated by Fiona Bradley for
The Fruitmarket Gallery and
Nigel Prince, assisted by
Anna Pike, for Ikon Gallery.

The Fruitmarket Gallery,
Edinburgh
26 February – 1 May 2005

Ikon Gallery, Birmingham
8 June – 17 July 2005

Exhibition supported by
The Elephant Trust, The Foyle
Foundation, The Henry Moore
Foundation and the Scottish
Arts Council Lottery Fund.

Photographic credits:
Patricia Bickers: p.85; Hugo
Glendinning: pp.6, 8–9, 10,
14, 17, 19, 20; Alexander
Gümbel: p.103; Matthias
Herrmann: pp.55, 59; Steven
Kirby: (artwork) p.84; Gary
Kirkham: p.74; Reto Klink:
p.68; Akahito Matsumoto:
pp.56–57; Dave Morgan:
p.71; Kohji Ogura: p.79; Sue
Ormerod: pp.12–13; John
Riddy: pp.36–37, 39, 74;
Stephen White: pp.30–31, 40,
78; Edward Woodman: p.64

Works courtesy of Lisson
Gallery, London, the Artist,
Patricia Bickers, Jack
and Nell Wendler, Tate
Gallery, London

Contents

After Salutation, observing me to look earnestly upon a Frame, which took up the greater part of both the Length and Breadth of the Room, he said perhaps I might wonder to see him employed in a Project for improving speculative knowledge by practical and mechanical Operations [...]. Everyone knew how laborious the usual Method is of attaining to Arts and Sciences; whereas by his Contrivance, the most ignorant Person at a reasonable Charge, and with a little bodily Labour, may write Books in Philosophy, Poetry, Politics, Law, Mathematics and Theology, without the least Assistance from Genius or Study. He then led me to the Frame, about the sides whereof all his Pupils stood in Ranks. It was twenty Foot Square, placed in the middle of the Room. The Superficies was composed of several bits of Wood, about the bigness of a Die, but some larger than others. They were all linked together by slender wires. These bits of Wood were covered

on every Square with Paper pasted on them, and on these Papers were written all the Words of their Language in their several Moods, Tenses and Declensions, but without any Order. The Professor then desired me to observe, for he was going to set his Engine at Work. The Pupils at his Command took each of them hold of an Iron Handle, whereof there were forty fixed round the Edges of the Frame, and giving them a sudden turn, the whole Disposition of the Words was entirely changed. He then commanded six and thirty of the Lads to read the several Lines softly as they appeared upon the Frame; and where they found three or four Words together that might make part of a Sentence, they dictated to the four remaining Boys who were Scribes. This Work was repeated three or four times, and at every turn the Engine was so contrived, that the Words shifted into new places, as the square bits of Wood moved upside down.

Jonathan Swift, *Gulliver's Travels*, 1726, (Penguin Classics, 2003, pp.170-171)

KURT WALDHEIM

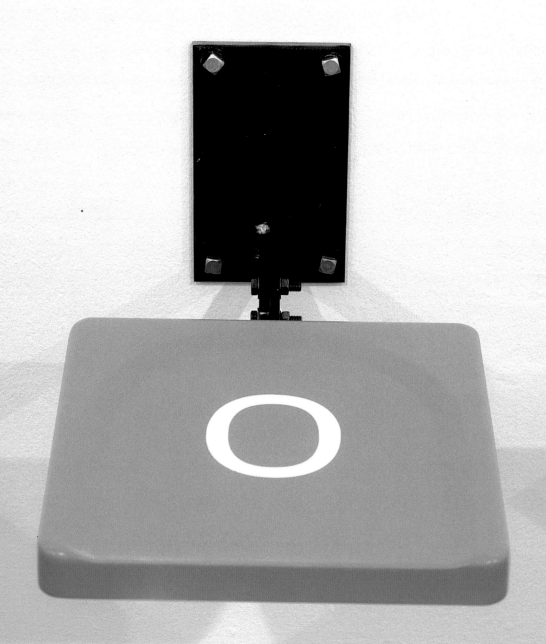

General Assembly

Fiona Bradley

Swift's account of Gulliver's introduction to the life's work of the Lagado Academy's Professor in Speculative Learning is an elaborate literalisation of the metaphorical construct of the monkey with the typewriter, who, given enough time, could, 'without the least assistance from genius or study', write Shakespeare. Swift's description sets the tone for Gulliver's further investigations of the work of the Academy, a sequence of finely-observed satires serving clearly to demonstrate the writer's mistrust of human learning and its manifestation in the spoken and written word (of which he regards himself, of course, as a master).

Simon Patterson's *General Assembly* (1994) might almost have been designed from a brief set by Swift's Professor. An engine for the processing of information, the apparatus of its construction provides a frame for the viewer's encounter with the ideas at large in the work itself, and in works made both before and after this key installation.

General Assembly was commissioned by Jonathan Watkins for Chisenhale in London as part of an enlightened series of exhibitions seeking to offer young artists the opportunity to make substantial, gallery-based work. It was Patterson's first major sculptural installation, and it advanced his practice considerably, both in its own terms and in those of its public reception, offering audiences a tangible arena in which to

opposite:
General Assembly, 1994
(detail)
pp.6–20: installation view,
Chisenhale Gallery

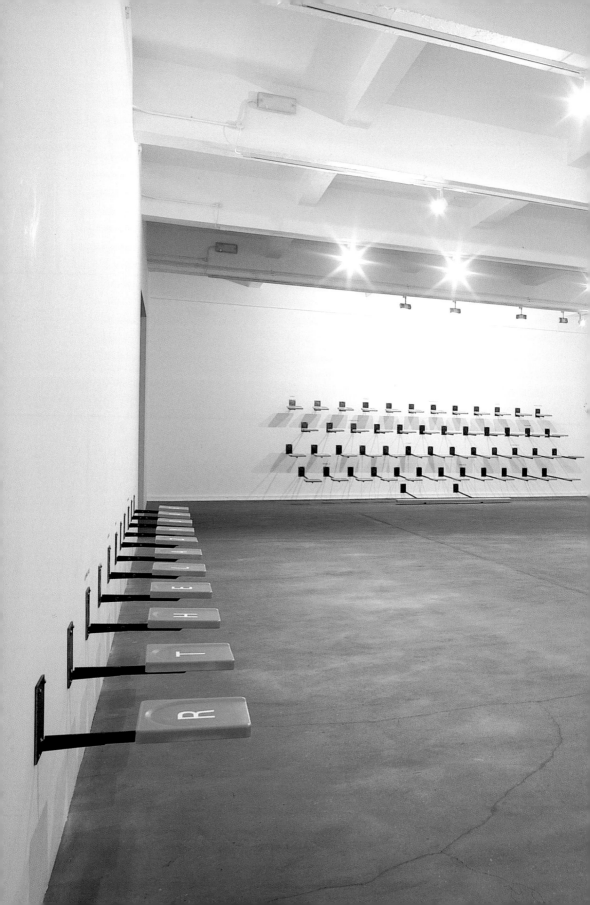

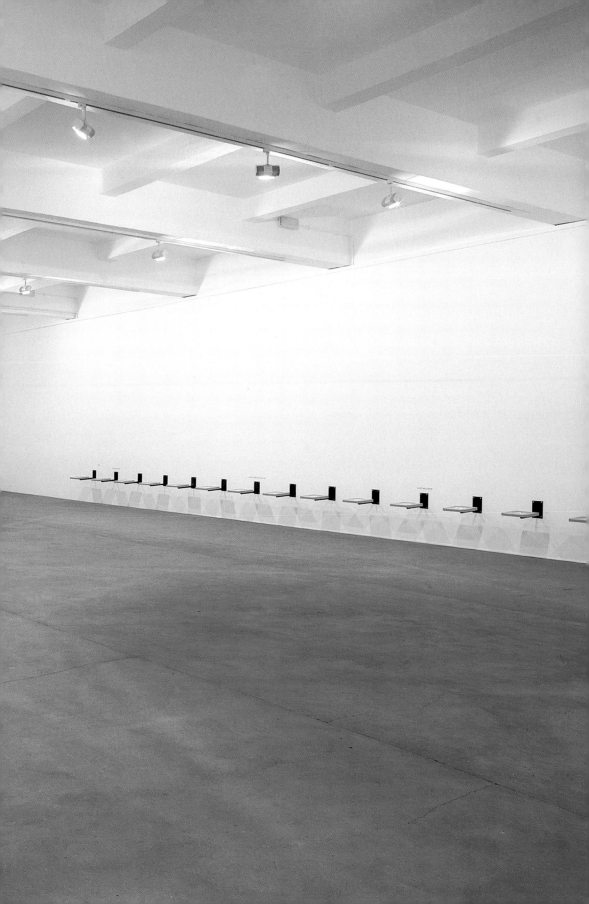

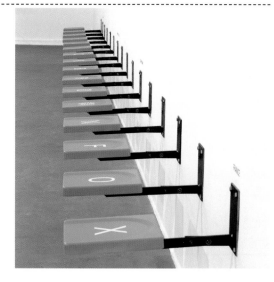

10

confront the artist's major concerns. Although it has not been seen in Britain since the year it was commissioned, *General Assembly* continues to loom large within Patterson's oeuvre and still, arguably, represents the best conceptual space within which to consider his practice. The charge it detonated in Chisenhale still resounds in the memory, affecting, for those who saw it, subsequent encounters with the artist's work. The piece is at the heart of the two overlapping exhibitions that together attempt to give an account of Patterson's work to date and which have given rise to this book – one in The Fruitmarket Gallery in Edinburgh, in which *General Assembly* occupies the entire top floor of the Gallery, offering actual and conceptual space in which the viewer may process the wealth of visual information offered by the works on display downstairs, and one at Ikon Gallery in Birmingham, from which *General Assembly* is palpably absent.

The work consists of 76 individual structures bolted to the wall. At one end of the installation, 50 of the structures are arranged like the keys of a classic Olivetti Lettera typewriter, each printed with one of the letters of the QWERTY keyboard, complete with return key and space bar. Around the other three sides, the remaining 26 structures are evenly spaced in a single line to spell out the classic learn-to-type sentence 'the quick brown fox jumps over the lazy dog'. The structures are all blue – Ford blue – with the exception of the return key, which is Mercedes red, and the typeface in which the letters on them are printed in Univers 55. Everything about the installation is as standardised, as universal, as reproducible and transparent as the artist could make it.

In scale and arrangement, the structures that make up *General Assembly*, in perpetual motion as they are between typewriter keys on the one hand and a kind of colour-branded stadium seating on the other, set the stage for some key event that seems always about to take place. The viewer's encounter with the work is inevitably performative – at Chisenhale, the installation layout brought the viewer into the work near the 'typewriter'; at The Fruitmarket Gallery, the viewer rises up into the work via the staircase right in the centre. Before knowing what the work might be about, the viewer finds themselves part of it, a participant in whatever it is that might be about to take place.

And what does take place is the rehearsal, and continuous re-rehearsal, of a sequence of systems by which we attempt to make sense of the world we inhabit and for which we are responsible. *General Assembly* sets a stage on which the central ideas of Patterson's practice are played out; his unravelling of systems of classification, description, behaviour and belief. The highly-

charged space at the work's centre, empty of anything except the viewer, gives it its importance within Patterson's work, allowing it to function as a space into which his ideas may be projected forwards or reflected back.

The title of the work casts it immediately into the arena of the United Nations – a system, ostensibly, for the keeping of world peace. The General Assembly is the annual meeting of all member states of the UN, an event which takes place from the third Tuesday in September until mid-December. That the UN's is in fact the assembly that is referenced here is confirmed by the work's further play on the idea of seating – above five of the structures are printed the words China, Russia, United States, France and Great Britain, the five nations (the five victorious powers of World War II) with permanent 'seats' on the UN security council. They are joined by the names of all the Secretary Generals of the UN since its inception, the curiously resonant names – from Trygve Lie to Boutros-Boutros Gali – that chart the history of global conflict from 1946 to 1994.

Politics, and especially political history, is a system for the classification, communication and manipulation of information. Essentially, it is a belief system, and, as such, is inevitably subject to partiality. The General Assembly brings together as many perspectives on the global situation as there are member states, each representative a piece in a vast chess game, the rules of which keep changing. Permanently hosted by a nation which fails to pay its subscription, is tardy in signing up to environmental agreements and is famously gung-ho in its approach to global peace-keeping, the UN as a force for good is a morass of constantly shifting ideals and possibilities.

Alongside politics, in *General Assembly* Patterson identifies sport as a second system through which national and international identity, expansionist aspiration and collaboration/competition may be channelled. On 20 March 1994, Lieutenant General Sir Michael Rose, commander of the United Nation Protection Force (UNPROFOR) in Sarajevo, organised a football match between an UNPROFOR team and one representing Sarajevo City. The match took place in the Sarajevo Football Stadium on the occasion of the joint EU/UN negotiated cease-fire. In celebration of the promise of peace, a symbolic combat was staged, signalling the combative nature of world relations, and the way in which competition is enshrined in so many of our institutions and systems.

The aspirations and achievements of the UN as a force for global peace and mutual understanding are further undermined by Patterson's seemingly arbitrary additions

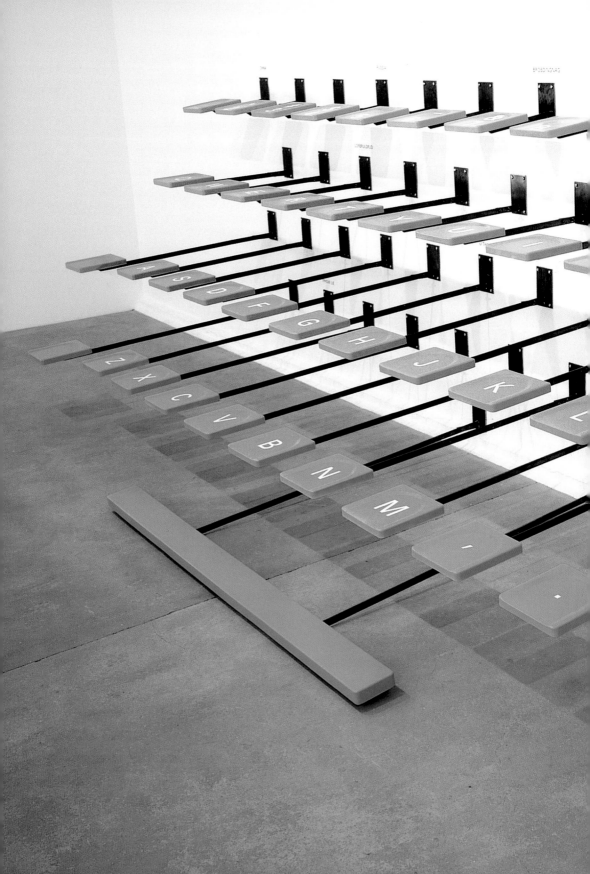

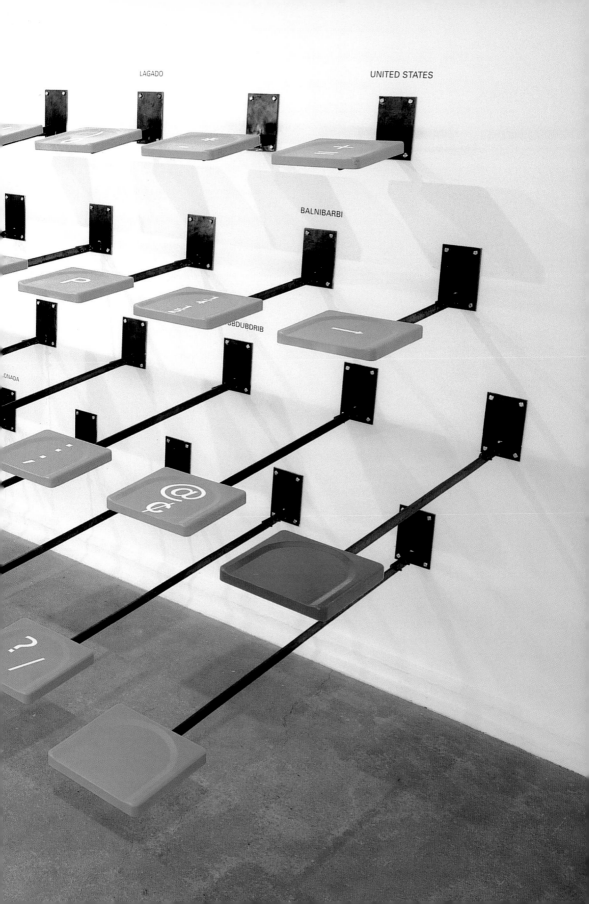

to the nations with seats on its security council. The five post-war super powers are joined by Straits of Sunda, Brobdingnag, Lorbrulgrud, Balnibarbi, Lugnagg (twice, in two different spellings), Houynhms Land, Lagado, Glubbdubdrib, Lilliput and Maldonada. These are all places from *Gulliver's Travels*, planted like secret weapons or spies among the signifiers of the UN, infiltrating the assembly and sowing seeds of satire and suspicion.

Some of Patterson's additions to the UN Security Council are countries – Lilliput, land of little people, the first and best-known of Gulliver's destinations; Brobdingnag, land of giants; Houynhms Land, whose inhabitants have the form of horses; and Balnibarbi. Others are towns, almost all of them – Lagado, Lorbrulgrud, Maldonada, Luggnagg – variations on London, expressed in the language of the land in which Swift locates them. Each of the lands Gulliver visits has its own language, and learning it is invariably his first task. *Gulliver's Travels*, though first and foremost a political satire, takes the travel book as its form, and Swift takes great care to invent plausible languages with rules ('the quick brown fox....') and consistencies within the nonsense. The words he invents are often anagrams ('the quick brown fox...' again, an anagram for the entire alphabet), complicated by substitutions of letters allowed according to an arbitrary yet rigid system for the substitution of consonants.

Balnibarbi is the land in which Gulliver, and therefore Swift, discourses the most on the subject of language. The inhabitants of Balnibarbi are people whose 'Minds are so taken up with intense Speculations' that they can neither speak nor listen without having their mouths or ears 'flapped' by a servant (a 'flapper') with a container of dried peas. Anyone – Gulliver for example – who appears to have no need of a 'flapper', is deemed to be unintelligent. The Academy of Lagado is in Balnibarbi, and there the Balnibarbians attempt to find a universal language based on irreducible 'things'. First they collapse language 'by cutting Polysyllables into one, and leaving out verbs and Participles, because in reality all things imaginable are but Nouns'. In practice, this would lead to a language consisting only of the words that Swift – according to the typographical conventions of his day – capitalises. Then, in order to preserve 'Health as well as Brevity', the Balnibarbians propose that language be abandoned altogether, the names of things to be replaced by the things themselves, 'an Universal Language to be understood in all civilized Nations, whose Goods and Utensils are generally of the same kind, or nearly resembling, so that their Uses might easily be comprehended. And thus Ambassadors

would be qualified to treat with foreign Princes or Ministers of State to whose Tongues they were utter Strangers'. (p.174)

Swift's description of the various projects of the Academy parodies the numerous attempts made in his own time to define a universal language. Patterson's reference to it in a work dominated by the signs and signals of language, the very letters that are its building blocks, both recalls similar attempts made in our time (the essay written to accompany *General Assembly*'s original presentation was translated into Esperanto, and is published for the first time in that language in this volume) and identifies language as the ultimate system for the control and communication of information – and a belief system at that.

Language is based on consensus – even speakers of a common language may communicate only because they agree that certain conventions shall be held to be true (that the configuration of letters T-R-E-E shall always signal the same object with the green leaves). Consensus may shift, and is inevitably both partial and partisan, and Swift's Balnibarbians, in deciding to use the thing rather than the thing described, were attempting to reduce such slippage and eliminate language's inevitable basis in mutual trust. The UN could do with such a system, and Esperanto tried to provide it, as does the adoption of English as the national language of politics, navigation and war. However both systems are inevitably imperfect, and the UN at least relies on an army of translators, modern-day counterparts of Swift's 'flappers' perhaps, and personifications of linguistic trust, who deal in imperfect equivalences and substitutions.

Patterson's *General Assembly* is constructed in terms of universals – the classic typewriter, typeface, colours; the standard keyboard layout, the alphabet, the archetypal sentence. Made as an engine for creating and communicating ideas, it reveals that engine ultimately to be language itself – the thing expressed inevitably manipulated by the form of its expression. However universal its aspiration, *General Assembly*, like the UN, the rules of football and *Gulliver's Travels*, is a system like any other. An elaborate framing device, it sites within it its creator's understanding that the process of processing information is as fundamental to the impact of the information as the information itself.

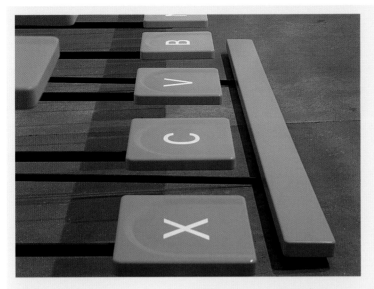

Senserce

Patricia Bickers, 1994
Translated by W. Auld

Kiel gesto, kiu intencis signali revenon de normaleco rezulte de la batalĉeso en Sarajevo kune negocita de EU/UN, Generalo Sir Michael Rose aranĝis futballudon en la damaĝita sed ankoraŭ staranta stadiono. En tiu pli malgranda areno, sub egido de l' ĉielblua kaj blanka koloroj de UN o, okazis riteca batalo nome de la paco inter du teamoj, el kiuj unu konsistis el soldatoj de la UNa Packonserva personaro, la alia el travivintaj membroj de la loka futbalteamo.

Ĝenerala Asembleo memorigas pri la kunigo far la Generalo de tiuj du porokazaj teamoj. Ne la unuan fojon, ke Simon Patterson utiligis futbalon metafore. Inspirite de la Monda Pokalkonkurso 1990, en kiu Anglion memorinde venkis Germanio je penala ŝotado dum duonfinalo, Patterson starigis sian propran ludon inter du rivalaj teamoj en *La Fina Vespermanĝo Aranĝita laŭ la Posteniĝo Balaista (Jesuo Kristo en golejo)* kaj *La Fina Vespermanĝo Aranĝita laŭ la Posteniĝo Kvararierula (Jesuo Kristo en golejo)*, 1990. Konvene, pro la ĝemelaj italaj pasioj pri futbalo kaj religio, ambaŭ *Finaj Vespermanĝoj* estis eksponitaj kune la unuan fojon en Italio, en la sekcio Aperto de la Venecia Biennale 1993[1]. La itala traduko de 'posteniĝo balaista', 'il modulo libero', emfazas la fundamente malsamajn alirojn al la ludo reprezentataj de la du teamoj starigitaj unu kontraŭ alia: sur la dekstra muro, la aperta ludplano de l'eŭropanoj lasas liberan ludadon al la mezaj ludantoj, Judaso kaj S-ta Petro; maldekstre, la dogmema kroĉiĝo Anglio al la flegma posteniĝo kvararierula kondamnas ilin al la flanksidado sur la benko anstataŭula.

La du posteniĝoj reprezentas ankaŭ la du konkurantajn dogmojn rilate la Eŭkaristion: konsubstancion kaj transsubstancigon, kiuj iam militigis eŭropanojn inter si kaj ankoraŭ disigas Protestantojn disde Romkatolikoj. (Uzado do l' usona literaro Tajpilo, literaro moderna tamen jam eksmoda, tuj aludas tiel la persistadon kiel la senutilon de tiu disputo.[2] Samtempe, la kontraŭmetado de l' du ludantaroj povas esto vidata ankaŭ kiel alegorio pri la rilatoj de Anglio al la cetera Eŭropo, kiuj lokigas Brition kiel tuton ĉe la flanklinioj. Eĉ se tio eblus, ne estas intenco de Patterson forbari alternativajn interpretojn pri tiu ĉi aŭ ajna alia verko. Male, la formoj, laŭ kiuj la verkoj estas intence elektitaj pro iliaj klareco kaj konateco, kiel la ludplanoj publikigataj en ĵurnaloj sojle de grava ludo. Stariginte sian propran ludplanon, iu ajn rajtas ludi.

La batalema naturo de politiko estas sanktigita en niaj institucioj, faktoro je kiu Patterson elektis ludi en du parencaj verkoj: *La Supera Parlamenta Ĉambro* kaj *Staatschiff/Ŝtatŝipo*, ambaŭ 1993. Unu estis komisiita por libro kun titolo *L'Endroit Ideal*, la alia estas murdesegnaĵo. Patterson ironie interpretis 'la lokon idealan' kiel 'la lokon alian', la Superan Ĉambron, kaj konceptis la sidlokojn Registarajn kaj Opoziciajn, ne kiel du kontraŭantajn teamojn, sed kiel du herbecajn ĝardenajn randojn plenigitajn de harditaj staŭdoj. Tiel, ekzemple, la Tronon okupatan de l'prezidanto kiam ne ĉeestas la Reĝino, la Regnestro, reprezentas Flogo; la du antaŭaj benkoj ĉe la Registara flanko, rezervitaj al la Episkopoj, estas okupataj de Kampanoloj (*sonoriloj de Canterbury*); La Transaj Benkoj de Skrofularioj Nodozaj (*figherbo*); la Opoziciaj Benkoj

Ĝenerala Asembleo, 1994
(detalo)

de la tenacaj Heliantemoj (*roka rozo*), komprenebie, dum la Kabineton de l'Ĉefpedelo okupas la Kniphofio (*ruĝarda fajragitilo*) kaj la Jurnalistan Galerion Erigeronoj (*pulveneno*).[3]

Staatschiff/Ŝtatŝipo intence almensigas mezepokajn imagojn pri la 'ŝipo da stultuloj'. Tiu ĉi ŝipo, tamen, baziĝas sur usona Boeing 747 'elefanta' jeto – oblikva aludo, eble, al la vera karaktero de la 'speciala rilatigo' inter Britio kaj Usono – kvankam pro tio, ke la sidloka plano baziĝas sur British Airways 747, ĝi probable havus motorojn Rolls Royce. Ĉifoje la Trono lokiĝas, kie normale situas la necesejo – ĉi tie signita per 'T'; en la meza sekcio de l'torpedoforma aviadilo, kaj la Ĉambra Tablo, Depeŝaj Skatoloj kaj Transaj Benkoj kie, se ne en la Kuirejo? Elmetitaj unu kontraŭ alia, ambaŭflanke de la kuirejo, estas la Benkoj Registaraj kaj Opoziciaj – la rezervaj teamoj.

La gesto de Generalo Rose, kiam li kunvenigis la ludon en Sarajevo, substrekis la fakton, ke sporto kaj politiko estas nemalimplikeble kunligitaj, ke futbalo ne estas 'nura ludo'. Se parafrazi la faman diraĵon de von Clausewitz pri milito, futbalo estas nenio alia ol daŭrigo de politiko alirimede, kaj politiko estas la finlasta ludo. En tiu ĉi ludo, tamen, estas malfacile esti certa, kiuj estas ludantoj, kiuj estas spektantoj. Multe da aktuala arto antaŭmetas al spektanto tiun saman dilemon kaj ambaŭ estas dramigitaj en *Ĝenerala Asembleo*.

Enirante la arenon spektanto povas, almenaŭ mense, elekti sidlokon, ĉu en la ĉefa spektantejo, ĉu ĉirkaŭ la periferio, kaj ĝui la spektaklon proponatan de la densaj vicoj da seĝoj UNe blauj kaj blankaj interrompitaj nur de la sola helruĝa. La homa skalo de la

verko ankaŭ ebligas al spektanto taksi *Ĝeneralan Asembleon* laŭ kriterioj tradicie skulptaj. Kiel skulptaĵo ĝi funkcias ie inter reliefo kaj skulptado izola, kvankam ĝia dependado de la muroj, al kiuj ĉiu parto estas fiksita, klare neas la eblecon, eĉ la dezirindecon, de kompleta aŭtonomio. La lingvo de skulptado estas laŭlitere inkluzivita en la verkon per la titolo, kiu aludas al la konstrua metado, al la 'spacstango' kiu trudiĝas plej foren en la galerion tie, kie ĝi malabrupte ŝvebas super la planko.

Por kvalifikiĝi kiel ludanto, nur necesas, ke la spektanto engaĝiĝu al la verko. La alia evidenta aspekto de *Ĝenerala Asembleo*, tiu de giganta tajpilo sur kiu la 'seĝoj' iĝas 'klavoj', aperte invitas la spektantojn verki propran tekston[4]. Tiu helruĝa klavo, ekzemple, estas la 'tabeligilo', el la latina *tabula* signifanta skribtabulon. (Tabeligi signifas redukti informojn laŭ formo de tabelo aŭ resumo – eble tordita aludo al la praktikado de l'artisto mem.) La saĝeto sur la 'retroklavo' indikas helpeme la direkton de la unua vorto de la konata propozicio, kiu enhavas ĉiujn literojn de la angla alfabeto THE QUICK BROWN FOX JUMPS OVER THE LAZY DOG. Iu ajn lerninta tajpi eble sentos tiki siajn fingrojn pro rememorita reago.

La artisto estas ekmovinta la aferon: la nomoj de ĉiuj kvin nacioj kun permanentaj sidlokoj en la Sekureca Konsilantaro de UNo estas kunigitaj, la plej gravaj en la supra vico/etaĝo de la ĉefa spektantejo: ĈINIO, RUSIO kaj USONO (US), sed inter la du lastaj estas enŝovitaj: BROBDINGNAG la fikcia lando de la Gigantoj en la politika satiro de Swift, *Vojaĝoj de Gulivero*, kaj LAGADO, la ĉefurbo de BALNIBARBI (lokigita super la klavo $1/4$ / $1/2$ en la dua vico/etaĝo). La malpli gravaj ludantoj lokiĝas ĉe la

periferio: FRANCIO super la 'X' de FOX kaj GRANDA BRITIO super la 'O' de OVER je unu klavo/seĝo preter LILIPUT, la lando de nanoj, lokigita super la 'P' de JUMPS. Iuj el la nomoj, tiuj de Perez de Cuellar kaj Kurt Waldheim regule aperas en la verkoj de Patterson, sed ĉiuj, inkluzive de U THANT kaj Sro BOUTROS-SPACO-BOUTROS, estas antaŭaj aŭ, kaze de tiu lasta, oficanta Ĝeneralaj Sekretarioj de la Unuiĝintaj Nacioj, kaj tiupostene prezidis la redesegnadon de l'politika mapo laŭ formoj ne malpli strangaj ol tiuj de Swift.

La litertipo estas, komprenebie, Univers 55. 'Komprenebie' ĉar futbalo jam fariĝis la sporto 'universala', fakto agnoskita de Usono kiam ĝi konsentis surscenigi la Mondan Pokalkonkurson 1994. Kiom ajn la termino senvaloriĝis, kaj malgraŭ la provo de Dro Zamenhof starigi Esperanton kiel alternativan, tamen ankoraŭ europan, lingvon, la angla fariĝas la lingvo 'universala' de internacia politiko. La malsukceson de Dro Zamenhof paralelas tiu de la Balnibarbianoj, kiuj klopodis trovi alternativon al lingvo skribata, parte pro tio, ke ĝi servus 'kiel universala lingvo komprenota en ĉiuj civilizitaj nacioj'. La unua projekto alprenita de la Lernejo pri Lingvoj ĉe la Akademio de Lagado estintis redukti lingvon ĝis la namoj de obektoj, 'ĉar ĉio imagebla estas reale nur substantivoj'.

La posta stadio estis tute rezigni pri vortoj, 'ĉar vortoj estas nur la nomoj de objektoj, estus pli oportune se ĉiuj homoj kunportus kun si tiajn *objektojn*, kiaj necesus por esprimi la aktualan aferon, kiun ili pridiskutos'.

Artistoj jam delonge komprenas la potencon de 'vortoj kiel objektoj' same kiel portantoj de signifo. Eble ĉiuj artistoj estas Balnibarbianoj – Swift mem

Notoj

1. *La Fina Vespermanĝo Aranĝita laŭ la Posteniĝo Balaista (Jesuo Kristo en golejo)* estis unuafoje eksponita, aparte, ĉe la Galerio Milch, Londono, 11 Augusto – 1 Septembro 1990.

2. Patterson tuŝas la religian signifon de la *Lastaj Vespermanĝoj*, specife rilate al komkurantaj dogmoj pri la Eŭkaristio, dum surbendigita intervjuo kun Liam Gillick, *Audio Arts Magazine*, Vol.13, N-roj 2 & 3 Septembro 1993, flanko 3 kaj vidbende en *Untelevision: Venice Biennale, The Cardinal Points ot Art* 1993, Numero 2.

3. *La Supera Parlamenta Ĉambro* estis komisiita de Eric

Troncy kaj estis eldonita en *L'Enciroit Ideal*, Red. Eric Troncy, L'Ile du Roy, Centre d'Art et Jardin, Val de Reuil 1993. La fonto de l'desegnaĵo pri la Supera Ĉambro estas *Aspects of Britain: Parliament*, eldonita de HMSO, 1991, p. 112. La floroj estis elektitaj el *The Dictionary ot Garden Plants*, de Roy Hay (tiel) kaj Patrick M. Synge (ĉu paranco de J M Synge?) kun antaŭparolo de Lordo Aberconway V.M.H. kaj eldonita kunlabore kun la Reĝa Hortikultura Societo, Londono, 1969 kaj 1975. Staatschiff/Ŝtatŝipo estis eksponita ĉe Galerio Gruppe Grün, Bremen, dum 1993.

4. La seĝoj estis fabrikitaj por The Educational Furniture and Supplies Company. La esenca diferenco inter la klavoj de la skribmaŝino, laŭ kiuj estis modelita *Ĝenerala Asembleo*, kaj la seĝoj estas, ke la levita rando estas turnita 180° laŭ la horizontala nivelo.

5. La fonto de ĉiuj aludoj al *Gulliver's Travels* de Jonathan Swift devenas de la sama malmultekoŝta broŝurita eldona, *Gulliver's Travels*, Wordsworth Classics 1992. La citaĵoj estas laŭ pp.197-98, la du alternativaj literumoj de Luggnagg / Lugnagg aperas sur la enhavopaĝo Parto III, Ĉapitro 1, kaj en la mapo sur

priskribas sian frenezan profesoron ĉe la Lagado-Akademio kiel la 'universalan artiston'. En Ĝenerala Asembleo, kaj, argumenteble, en ĉiuj siaj verkoj ĝisnunaj, Patterson malkonstruas sistemojn, de kiuj ni kutimiĝis dependi – mapojn, diagramojn, taksonmiojn, konstelaciojn, flagojn, sistemojn kalkulajn, mezurajn kaj ortografian – memorigante al ni, ke ili estas ĝuste tio, sistemoj. Kaj tiom dependas de la funkciado de tiuj slstemoj; ekzemple, kial troviĝas du literumoj de LUGGNAGG?

(Ĝi estas literumita per kvar 'G-oj' la unuan fojon sed la duan por nur tri, kiel LUGNAGG super la 'L' kaj 'A' ĉe LAZY, respektive). Ĉu tipografiaj eraroj? Kaj se jes, kiu el ili estas ĝusta dum ambaŭ funkcias same bone? Jen unu el la multaj koincidoj suprenlanĉitaj de lia verkaro, la alternativaj literumoj origine rezultiĝis de eraro, sed konsultinte la originalon, la artisto konstatis, ke Swift uzis ambaŭ formojn, kio estas ne tiom surpriza, pro tio ke Vojaĝoj de Gulivero estis verkita preskaŭ tridek jarojn antaŭ ol Dro Johnson publikigis sian Vortaron, post kio la angla ortografio normiĝis[5].

Vortoj konsistigas la salan strukturon de unu el la plej fruaj ĉefverkoj de Patterson, Allahu Akbar el 1991[6]. Kiam ĝi estis la unuan fojon eksponita, la vortoj de l' titolo, Allahu Akbar (Granda estas Dio), estis rekte fiksitaj al la muro de aparta 'antaŭĉambro', dum la ĉefparto de la verko traarkis la longon de la tuta koridora muro: du kolonoj vertikalaj, malsame altaj, ligitaj per gracila horizontala linlo pendigita inter ili, formanta ponton eksterordinare belan. La kolono maldekstre konsistis el la nomoj de la Prezidentoj de Usono, laŭ kronologia ordo; la kolono dekstre, sub la rubriko 'Famaj Ŝtatmurdoj', listigas la nomojn

de famaj viktimoj ekde 'Senaĥeribo de Asirio 681 a.K' ĝis 'Julio Cezaro 44 a.K', super la horizontala linio, 'Kaligulo, Romia Imperiestro 41 p.K' ĝis 'Gen. Zia', sube. Pluraj nomoj en la maldekstra kolono reaperas dekstre, dum aliajn kunligas aliaj obazaĵoj en ties persona aŭ politika vivoj. La nomoj de '"Jimmy" Carter' kaj "Anwar Sadat" rekte unu kontraŭ la alia, etendiĝas trans la disaĵon laŭ maniero, kiu memorigas pri la historie grava Interkonsento de Tendaro David el 1978, kiun Patterson festis per pli frua verko, Sadat Carter Begin, kreita en 1988, je la deka datreveno de ilia renkontiĝo[7].

La horizontalan linion kunligantan la du kolonojn konsistigas la nomoj rilatantaj al du el la plej gravaj konfrontiĝoj inter Oriento kaj Okcidento, Kristanoj kaj Islamanoj: la Batalo ĉe Lepanto el 1576 kiu, kiel oni iam instruis al ĉiu lernejano, 'savis la Okcidenton de la Otomana Imperio', kaj la Golfa Milito de 1991. La ĉefaj protagoniatoj ĉeestas, historiaj figuroj traplektitaj de nuntempuloj, kune kun komentantoj kaj aliaj, ŝajne periferiaj figuroj, formantaj tragikan kontinuajon: Sulimano II ('La Grandioza' aŭ 'La Leĝdoninto'), Brig.-Gen. Richard Neal, Tariq Aziz, James Baker, Barbarossa ('Ruĝbarbulo'), Lia Imperiestra Moŝto Charles V, Philip II, Arhiduko Ferdinand I, Gen. Colin Powell, Gen. Sek. Perez de Cuellar, Jitzak Ŝamir, Prez. Assad, Marlin Fitzwater, Ismail I, Selim II 'La Drinkulo I', Raŝid Ali, John Suchet, Sandy Gall, Salman Ruŝdi, Fazad Barzoft – tiuj du lastaj metitaj inter 'Julio Cezaro' kaj 'Kalig-ulo' sur la dekstra kolono, la viktima flanko.

JP233 in C.S.O. Blue, farita dum la posta jaro, estas verko proksime parenca; efektive, versio plifrua, titolita simple JP233, estis farita dum la sama

jaro kiel Allahu Akbar. JP233 aludas al io teĥnike priskribata kiel 'dispela armilo', speco de 'armilo flughaven-rifuza' 'dispelata' de malaltflugaj trafaviadiloj Tornado dum la Golfa Milito. Trafante, la bombo eksplodas, liverante amason da bombetoj kaj minoj celantan krei maksimuman longedaŭran ĥaoson. Tamen ne gravas se la spektanto ne familiaras kun lastatempaj evoluoj pri tiel-nomataj konvenciaj armiloj. Ankaŭ ne gravas se la spektanto ne klare memoras la 'Tabulegon' en la Milita Ĉambro de la Pentagono en D-ro Strangelove; aŭ Kiel Mi Lernis Ĉesigi Zorgadon kaj Ami la Bombon de Kubrick. Same verŝajne ke al la spektanto estos memorigita Stelmilitoj au Stelmigro – 'Leonard Nimoy' troviĝas (ĝuste super 'Leonard Cheshire', sed sur alia trajektorio), kiel ankaŭ 'William Shatner', tempovojaĝulo inter 'William la Silenta' kaj 'William, Pr. de Oranĝo).[8]

Aliflanke, la alloge-sona, iomete melankolia titolo povas koloro eble memorigas pri Rapsodio en Bluo de Gershwin, aŭ, je unu paŝo pluen, la debatebla Nokturno je Nigro kaj Oro, Falanta Raketo[9] de Whistler. La artfajraĵoj eksplodantaj supren en la pentraĵo de Whistler multrilate analogas al la striaĵoj graci-arte eksplodantaj antaŭ la blua 'ĉielo' de JP233 in c.s.o. Blue. c.s.o. Blue, konata ankaŭ kiel Chromakey Blue, estas uzata de filmfaristoj kiel fono por superfilmado car ties opakeco, kaj rezultanta kapablo sorbi lumon, kreas potencan iluzion de tridimensieco; per tiu simpla rimedo, Patterson invitas la spektanton 'eniri' la verkon.

Kaj troviĝas tie io por ĉiuj: 'Dave Bickers', antaŭa Monda Ĉampiono de Motorcikla Strenado (Terena Motorciklado) kaj, pro peto de

p.162, respektive. Gulliver's Travels origine eldoniĝis en 1726. Dictionary of the English Language de Dro Johnson eldoniĝis en 1755. Patterson eldonis sian propran 'Leksikonon, Republicans (serio Artists' Book eldonita de Arefin Inc., Simon Patterson kaj Third Eye Centre, Glasgovo) en 1989, okaze de sia sol-ekspozicio ĉe Third Eye Centre, Glasgovo, 11 Marto – 22 Aprilo 1989.
6. Allahu Akbar estis farita por la sol-ekspozicio de l'artisto ĉe Riverside Studios, Londono, 27 Februaro – 14 Aprilo 1991. La teksto Letraset estas per Times Roman (Italic).

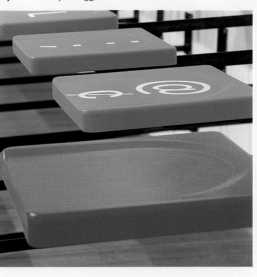

Ĝenerala Asembleo, 1994 (detalo)

l'artistofrato, 'Edward Turner', ĉefa planisto ce Motorcikloj Triumph dum ties ora epoko, Eble omaĝe al Fluglinio Delta, kiu havigis modelon por la verko, troviĝas 'Blériot' kaj 'Amy Johnson', kaj tiu super 'Papo Johano-Paulo', '"Pablo" Mason', la Tornado-piloto, kiu taksis sin ioma pentrartisto. Ĉu 'St Louis' estas tie kiel loko aŭ kiel persono? Ĉar ĝi estas lokita ĝuste super Amy Johnson, eble la nomo estas tie kiel eĥo de l'aviadilo de Charles Lindbergh, la Spirito de St Louis. en kiu li plenumis la uruan unupersonan flugon trans-Atlantikan? Dume George. Bill kaj Hilary Clinton ('George Clinton'? George 'Funkadelic' Clinton?) apenaŭ eniras, 'Ian Paisley' estas izolita kaj 'Kol. North' indikas 'Suden'.

En *Disvenkiĝo I*, titolita laŭ la batalpentraĵo de Paolo Uccello, la *Disvenkiĝo de San Romano*, en la Nacia Galerio, Londono, Patterson rekte aludas la noktan ĉielon, specife segmenton de la ĉiela ekvatoro inter 12 horoj kaj o horoj, kaj inter o° kaj 30°, enhavantan kelkajn el la plej konataj konstelacioj. La verko estas farita por ekspozicio ĉe Galerio Rodolphe Janssen en Bruselo dum la Brita Prezidenteco ĉe la EU. Preninte kiel komencan punkton la antropomorfismon kiu subkuŝas la Okcidentajn stelsistemojn, li renomis la konstelaciojn laŭ la EU-komisiitoj la plej grandan, *Leono*, laŭ la Vicĉefkomisiito, Leon Brittan; la demonigita kontraŭulo el Britio, la Ĉefkomisiito mem, Jacques Delors, anstataŭas *Canis Minor* (Hundon Malgrandan) kaj per memevidenta aludo al la 'du Germanioj', la konstelacio *Ĝemeloj* estas renomita Martin Bangermann. La noma de Frans Andriessen el Nederlando, kiel tiu de Leon Brittan, enhavas la literojn de konstelacio, liakaze *Aries* (Ŝafo). Koncerne al Ray MacSharry el Irlando,

kio li povus esti se ne *Oriono*? Kaj pro alia el tiuj koincidoj, kiuj iel servas por subteni la verkon, evidentiĝis, ke la bopatro de Rodolphe Janssen, Etienne Davignon, antaŭe estis EU-komsiito; li iĝas la 'supergiganta' stelo, Betelĝuzo.[10]

Patterson estis an Novjorko pro ekspozicio dum la Prezidenta Balotado de 1992, kio instigis lin refari la verkon. En *Disvenkiĝo II*, la konstelsciojn anstataŭas la nomoj de Usonaj Vicprezidentoj[11]. Ĉifoje, Dan 'Quayle metamorfoziĝas al *Canis Minor* (Hundo Malgranda), Al Gore al *Tauro*, dum Walter Mondale rimas je 'whale', do li devas esti *Baleno*, kaj Nixon neeviteble iĝas *Kankro*. En realo, kompreneble, iuj el la Vicprezidentoj Prezidentiĝis – ekzemple Nixon, dun aliaj estas forgesitaj, ekzemple Charles Dawes.

Ambaŭ ĉi verkoj estis kreitaj per kreto senpere sur nigratabula farbo,

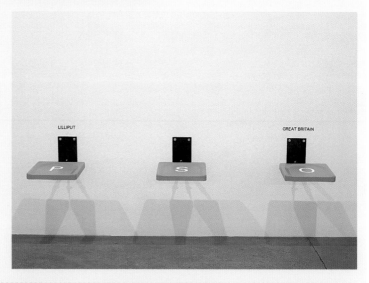

7. *Sadat Carter Begin*, silkekranaĵo sur tolo gipskovrita, estas unu el la serio da pentraĵoj komencitaj dum Patterson frekventis Kolegion Goldsmith, Londono. Dum la plimultaj estas pentritaj laŭ formato portreta. *Sadat Carter Begin* estas pejzaĝformata.

8. *JP233* 1991 estis unuafoje eksponita ĉe Galerio Transmission, Glasgovo, en grupa ekspozicio, 'Novaj Verkoj de Simon Patterson, Angus Hood kaj Thomas Walsh', 13–30 Aŭgusto 1991. *JP233 in c.s.o. Blue*, 1992, estis unuafoje eksponita en 'Doubletake: Collective Memory and

Current Art' (Duobla ekrigardo: Kolektiva memoro kaj aktuala arto), Galerio Hayward, Londono 20 Februaro – 20 Aprilo 1982 kaj denove en 'Doubletake: Kollectives Gedächtnis und Heutige Kunst', Kunsthalle, Vieno, 8 Januaro – 28 Februaro 1993.
D-ro Strangelove: aŭ Kiel Mi Lernis Ĉesigi Zorgadon kai Ami la Bombon estas farita nigre-blanke en la UR dum 1963. La rolo aktorita de George C. Scott aludas al la grandega surmura mapo de la tiama Sovetunio en la Milita Ĉambro de la Pentagono kiel la 'Tabulego'.

9. *Nokturno je Nigro kaj Oro,*

Falanta Raketo, 1877, estis tiu pentraĵo, kiu elvokis la faman komenton de Ruskin pri 'ĵetante poton da farbo en la vizaĝon de la publiko', pro kiu la artisto proesis kontraŭ la kritikisto. La artisto sukcesis je la proceso sed la ridinda aljuĝo de kvaronpenca kompenso kune kun la kostoj de la proceso bankrotigis lin.

10. La ekspozicio, titolita 'With Attitude' (Kun Sinteno), kun verkoj de Dominic Denis, Anya Gallacio kaj Simon Patterson, estis ĉe Galerio Rodolphe Janssen, Bruselo, 15 Oktobro – 14 Novembro, 1992.

11. Tiu rilatis al verko pli frua sur tolo *Usonaj Vicprezidentoj,*

unu el parencaj verkoj pli malgradaj sur tolo, kiuj estis inkluzivitaj en la ekspozicio 'With Attitude' ce Galerio Rodolphe Janssen; la ceteraj estis: *Duck Soup* (Anasa Supo), *Untitled Diptych* (Sentitola Diptiko) (It's a Knockout/Jeux sans Frontières) kaj verko diversperila, *Hearts or Oak* (Koroj Kverklignaj), ĉiuj el 1992.

Patterson starigis propran 'referendumon pri Eŭropo' en Milano, ĉe Galerio Gio' Marconi. Ĝi estis parto de la ekspozicio 'Il Mistero dei la Dollari Scomparsi' kuratorita de Liam Gillick, 3 Decembro – 30 Januaro, 1993. Afiŝoj estis

substrekante la nefiksitan naturon de la steloj mem kaj de la konstelacioj elpensitaj por mapi ilin, inkluzive tiun propran de la artisto. Por eĉ pli forte sentigi la punkton, en *Disvenkiĝo II*. Patterson utiligis tri pezajn moveblajn ekranojn, kiuj hazarde ĉeestis, ne sciante, tiam, ke la *Disvenkiĝo* en la Nacia Galerio estas unu eel tri panelaj de Uccello bildigantaj la batalon inter Florencanoj kaj Sienanoj ĉe San Romano en 1432. Jen alia koincido[12].

En la presita prezolisto sur la muro de la galerio en Novjorko, *'Rout'*, Disvenkiĝo estis misliterita kiel *'route'* (*irvojo*), ^ car usonanoj prononcas ambaŭ same (kiel siatempe, la angloj). Tiu, ne tute neantaŭvideblav, miskompreno liveras oportunan transiron al verko pli lastatempe: *Ŝoseaĵoj* (Roadworks), farita en 1993 responde al publikarta komisio de la urbo Givors, proksime al Lyons, por la Nacia Ŝoseo 86, kiu disduigas la urbon.

La antaŭan jaron, en verko komisiita par la franca magazino *Documents*, Patterson faris verkon surpaperan *Le Championnat du Monde (Le Grande Prix Brittanique)* (La Monda Ĉampioneco; La Granda Premio Britia), 'ŝosean verkon' bazitan sur la eldonitaj listoj de kvalifikaj tempoj par la brita Grand Prix de 1992. Longe antaŭ ol politikistoj komencis aludi al Eŭropo 'multlena' funkcianta 'diversrapide', Patterson enŝovis ilin an aŭtomobilojn kaj metis ilin ĉe la startejo de la konkurso Eŭropa. Ĉe la antaŭo, surprize, estas 'J Major (GB)' kun kvalifika tempo de 1 min 18.965 sek, sed stiranta iun Williams-Renault – komuna entrepreno angla-franca. Ĉe numero 4 estas 'H Kohl (GER) Benetton-Ford 1:22.066', ĉe la 10 estas 'J Delors (FR) Ligier-Renault' – entrepreno komplete franca. La itala Fiat Fiorino, ĉe numero

12, ĉiuokaze ne tre rapidus, sed ŝarĝite de tri stirantoj:'G Agnelli, G Andreotti, B Craxi', ĝia kvalifikiĝo estis bonŝanca[13].

Per *Ŝoseaĵoj*, Patterson povis transirigi verkon surpaperan al tridimensia 'realeco', krei el privata fantaziaĵo publikan laborajon, konvertante vojon tra la urbocentro en konkursejon. Per helpo de lokaj urbkonsilantaraj laboristoj, la startejo estis pentrita sur la vojo ĝuste antaŭ la trafiklumoj, rekone al tiuj junaj vetkurantoj, kiuj furioze rivoluigas siajn motorojn kvazaŭ ili stirus konkurs-aŭton Formulo 1. Laŭ la tuta la vojo, nigre-blanke kvadratitaj flagoj flirtis de la lanternfostoj, kie normale flirtas la Trikoloro dum naciaj festoj. La finlinio, ambigue signita de la vorto ARRIVEE, kaj nigra-blanka kvadrataro pentrita sur la vojo, situs apud, la Maison de Rhône – ĝuste kie finiĝas la rapidlimigo.

Nekrede, dum kreado de la verko la artisto eltrovis, ke la Mondĉampiono de Formulo 1, Alain Prost, devenas de najbara vilaĝo. Oni eĉ proponis inviti lin al la malfermo, sed Patterson atentigis, ke li eble estus okupata aliloke pro la Japana Granda Premio.

Dum temas pri koincidoj, post kiam li elektis la kolorojn, kiujn li volis por la klavoj/sidlokoj en *Ĝenerala Asembleo*, montriĝis, ke ili nomiĝas 'Ruĝo Mercedes' kaj 'Bluo Forda'. Ankoraŭ pil: kvankam la verkon parte inspiris dancosceno lau stilo de Busby Berkeley en la filmo de Merchant Ivory *Bombay Talkie*, el 1970, en kiu flave veatitaj gedancistoj elpasis trans la blankajn klavojn de giganta oranĝkolora skribmaŝino

'Menaka', la efektiva formo de la verko baziĝas sur tiu klasika portebla tajpilo Olivetti Lettera 32, kiun Patterson regule uzas. Iale ne trafis surprize eltrovo dum instalado de la verko, ke ne nur Olivetti

estis lanĉinta 'porjurnulan' tajpilon kun ĉielbluaj plastaj klavoj, sed ke Imperial nomis sian pli malgrandan modelon la 'liliputa'.

Plej el ĉiuj bona estas rakonto pri la Brazila 1994-Mondpokala ludistaro. Verŝajne en klopodo malstreĉigi tension inter la memdirite 'savanto' de Brazila futbalo, la brile dotita Barcelona sturmanto, Romario, kaj du el ties kunavanuloj, Bebeto kaj Muller, la direktisto proponis, ke en la aviadilo survoje al Usono, la ludistoj estu aranĝitaj laŭ iliaj surkampaj postenoj. Romario rifuzis senapelaĉle ĉar, laŭ unu versio, tio lokigus lin tro malproksime de luko, kvenkam laŭ alia versio la stelulo rifuzis ĉar tio lokigus lin meze de l' aviadilo inter siaj du malamataj rivaloj, Bebeto kaj Muller. Ŝajnas, ke la malamikeco de Romario al ambaŭ ludistoj, kaj aparte al la direktisto, datiĝas de kiam oni revokis lin, urĝege, por grava matĉo, kaj lasis lin ŝimi sur la anstataŭula benko ĉu la vito imitis arten?[15]

Ni vere ne devus supriziĝi pro ĉiuj ĉi koincidoj au rilatiĝoj, ĉar la verkaro de Patterson temas *pri* interligoj. Eĉ kiam li inversigas aŭ torde subfosas la informsistemojn laŭ kiuj ni vivas, tio estas nur por montri, ke ili povas daŭre funkcii en siaj novaj, egale laŭleĝaj, kunfigurajoj. Kiam publikigita, eĉ la plej hazarda aŭ arkana kunligeco, la plej privata aludo, povas sonigi en ni respondan agordon ĉar ni ne povas eskapi el nia historio, nia kulturo – mallonge, el ni mem.

presitaj, voĉdoniloj desegnitaj kaj du balotujoj estis konstruitaj kaj starigitaj sur stablotablo en voĉdona budo. La demando, pri kiu oni petis la voĉdonontojn decidi en *Balotoi* estis silogismo: 'Tutti gli asini sono quadrupedi; le mucche non sono asini dunque le mucche non sono quadrupedi', (Ĉiuj azenoj estas kvarpieduloj; bovinoj ne estas azenoj sekve bovinoj ne estas kvarpieduloj). En tia politika kunteksto, la afineco inter 'asini' kaj 'assassini' nepre estis rimarkita. Koncerne la kandidatojn, por la Supera Ĉambro, la Senato, tuta menaĝerio estis kunvenigita, konata pro

Disvenkiĝo I kaj II: ĝi inkluzivis leonon kaj hundon, kune kun iuj pli ekzotikaj specioj kiel kamelo kaj elefanto.
La kandidatoj por la Malsupera Cambro estis la EU-Komisiitoj.
12. La ekspozicio en Novjorko estis 'In and Out and Back and Forth' (Ene-Ele, Tien-Reen) starigita ĉe 578 Broadway, 5 Novembro – 5 Decembro 1992. La tri moveblaj ekranoj havis radetojn kaj mezuris po 12 futoj x 8 futoj. La ceteraj du paneloj el *Disvenkiĝo de San Romano* de Paolo Uccello, origine en la Palaco Medici-Riccardi en

Florenco, estas en la Galerio Uffizi, Florenco kaj Louvre, Parizo.
13. *Le Championnat du Monde (Le Grande Prix Brittanique)* estis komisiita de Eric Troncy por *Documents sur l'Art Contemporain*, Numero 1, Oktobro 1992, p.4.
14. *Ŝoseaĵoj* estis komisiita kiel parto de la projekto 'Art et Mêgalopole' por Givors, Francio en Oktobro 1993.
15. La versio de la rakonto laŭ kiu Romario rifuzis pro tio, ke estis lokita tro malproksime de luko estis rakontita en programo 'De nia propra Korespondanto', BBC Radio 4, Ĵaŭdon, 9 Junio 1994, je 11.30 atm (kiu rakontis ankaŭ la

historion pri Romario devigita trasidi ludon). La alia versio inkluziviĝis en la speciala suplemento 'Monda Pokalo 1994' al la ĵurnalo *Independent on Sunday*, 12 Junio 1994, p.6.

Manned Flight, 1999−

Dear Naomi Aviv,
My work for the Ein Hod Sculpture Biennial would entail the procurement or manufacture of a large man-lifting box kite (no more than 3m long x 1.3m high x 5m wide approx.) a Cody War Kite. (The Cody War Kite was invented at the end of the last century by Col. 'Buffalo Bill' Cody who was among many other things a pioneer of aviation). The kite was intended for military use; for example a team of these kites could be used to lift an observer several thousand feet to note enemy strength and disposition.

I intend the kite to be jammed in one of the olive trees in the Olive Grove in Ein Hod so as to appear as if the kite of an over-sized child had snagged in a tree.

The Ein Hod Biennial would be the starting point for the work since I intend it to tour to other appropriate locations. The kite must be photographed in each location so that this photograph can be displayed with the kite in its next new location. I hope that it will be shown over time in more and more places accumulating a 'history' in much the same way that a passport gains stamps or luggage becomes covered by baggage labels until ultimately, the more the piece is shown, the more travelled it will look until eventually it will become so battered and tattered that it will be wrecked.

The work could in theory pack into a cylindrical container 20cm in diameter x 300cm long, weighing no more than 20 kg and could be sent cheaply (by post) to the Biennal where it could then be assembled by me in situ. After the end of the exhibition the work can be dismantled and easily repacked and returned to me by post.

For other works that relate to this piece, see enclosed visual material.
Simon Patterson, London, 1999

Note:
The man-lifting Cody War Kite used in the work is one that I have inherited from a friend, who was British Kite-flying champion and flew to over 2000 feet in this kite. The white ripstop material used in modern kite making is the same as that used in spinnakers on yachts. Using yacht black vinyl lettering, coincidentally supplied by Saturn Sails of Glasgow Ltd., I placed the name of the Cosmonaut Yuri Gagarin on the larger facets of the kite making it redolent of advertising kites that were used at the beginning of this century. Yuri Gagarin (1934–68) completed the first manned space flight, orbiting the Earth in *Vostok I* on 12 April 1961. He died when his jet crashed on a routine training flight. In 1973 an asteroid in the constellation of Leo was named after him.

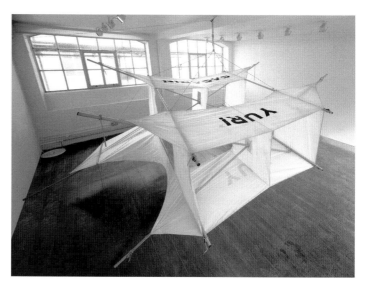

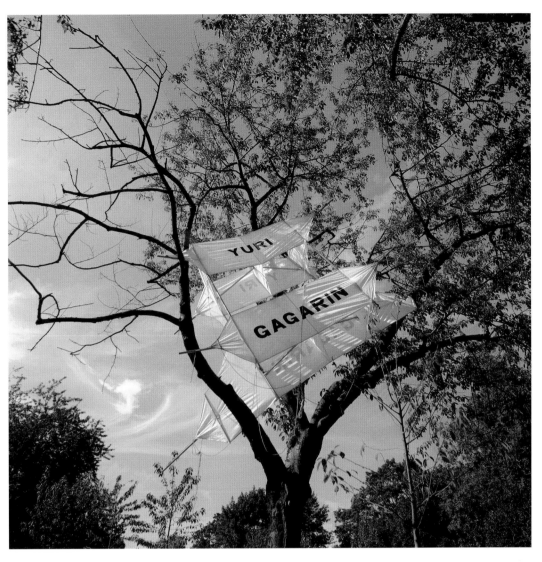

opposite:
Manned Flight, 1999–
Installation Fig-1, London,
2001

above:
Manned Flight, 1999–
Victoria Park, London, 1999

pp. 24–25:
Manned Flight, 1999–
Seoul, 2001
p. 26:
Manned Flight, 1999–
Sydney City Hall, 2002
Curated by Locus+
p. 27:
Manned Flight, 1999–
Lille, 2001
Curated by artconnexion

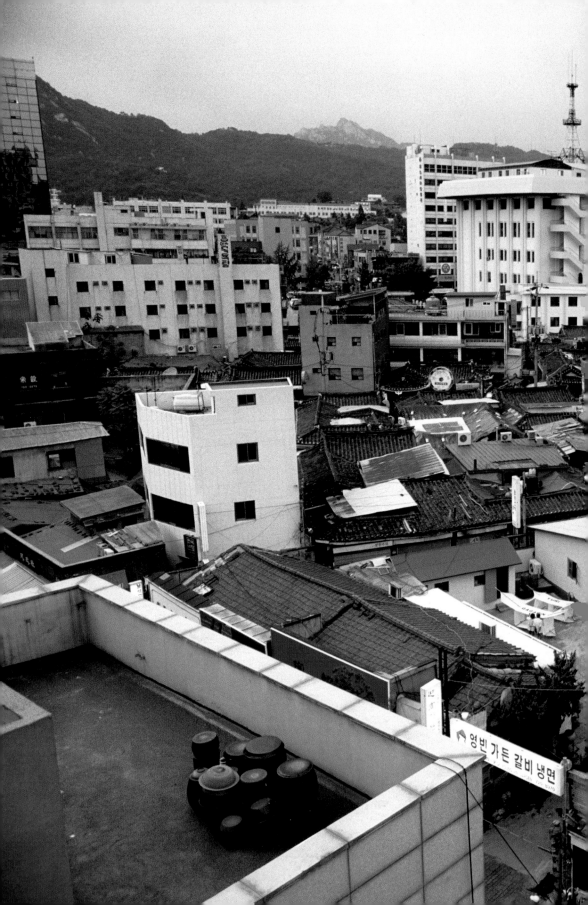

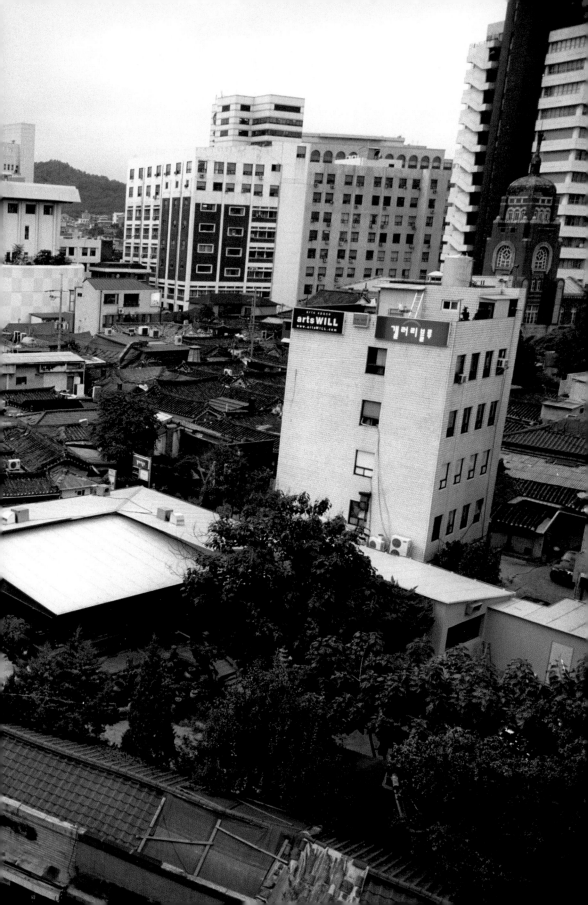

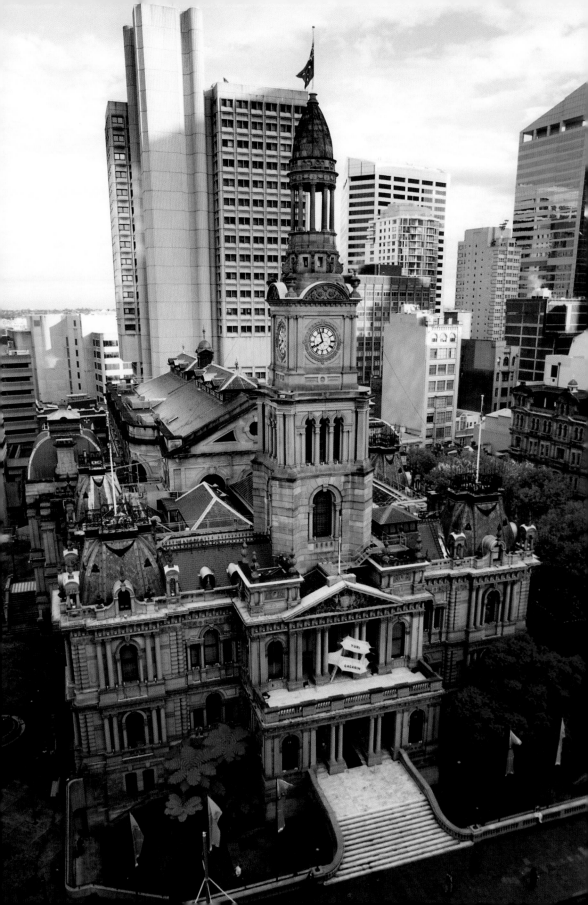

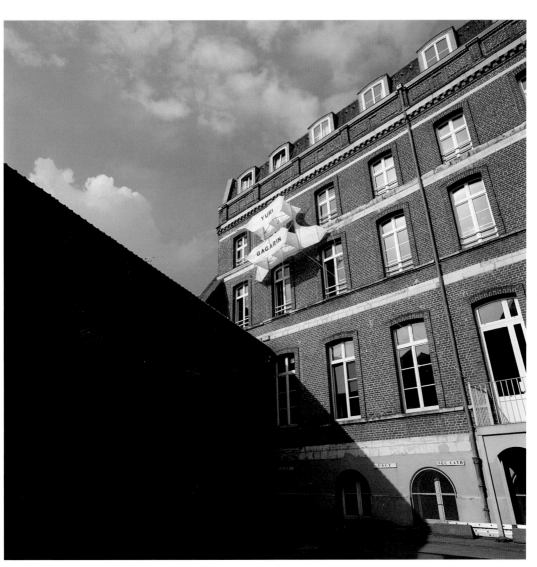

begat SALMON begat

BOOZ begat OBED begat

...ORE begat BACON...be...

...MORE begat BACONI be...

MACHIAVELLI begat ERASMUS begat MORE begat

TRILOBITES begat VERY PRIMITIVE FIS...

T

begat DAVID begat SOLOMON begat ROBOAM begat ABIA begat

BES begat DESCARTES begat SPINOZA begat

t ERYOPS begat ALOT begat MAMMALS begat AUSTRALOPITHECUS begat

E MACHINE

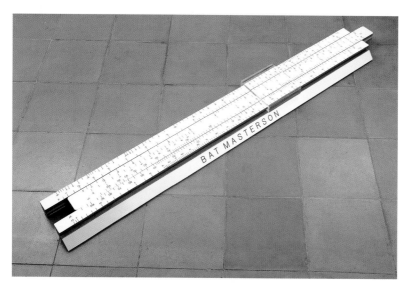

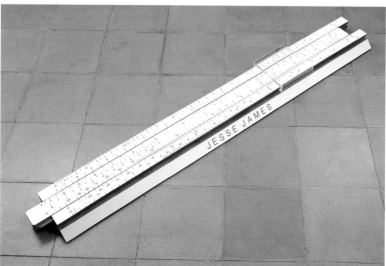

previous spread:
Time Machine, 1993
(maquette)
Collection Patricia Bickers,
London

clockwise from above:
*Gunmen; Jesse James, Bat
Masterton, Billy the Kid*, 1996
Courtesy Lisson Gallery,
London
and *Wild Bill Hickock*, 1996
Collection The British Council

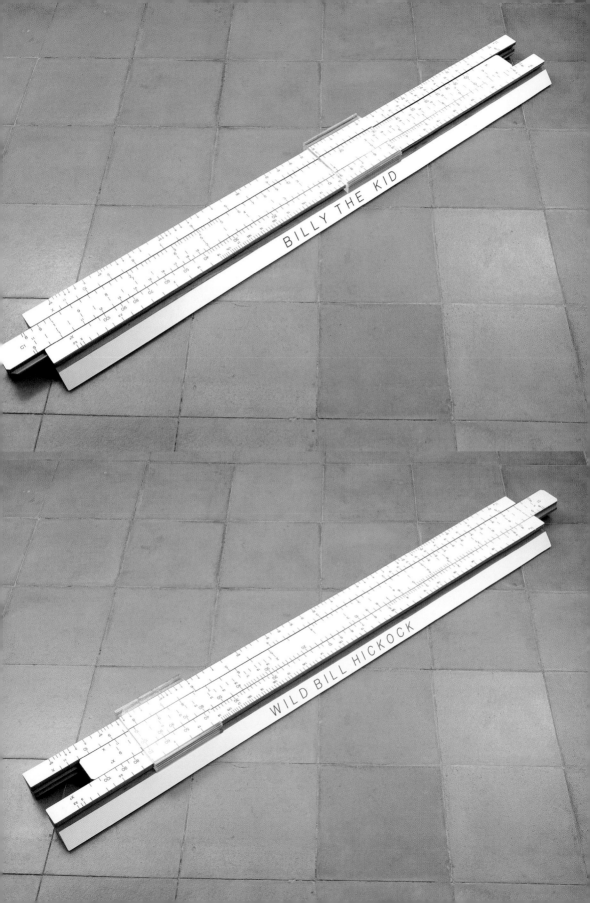

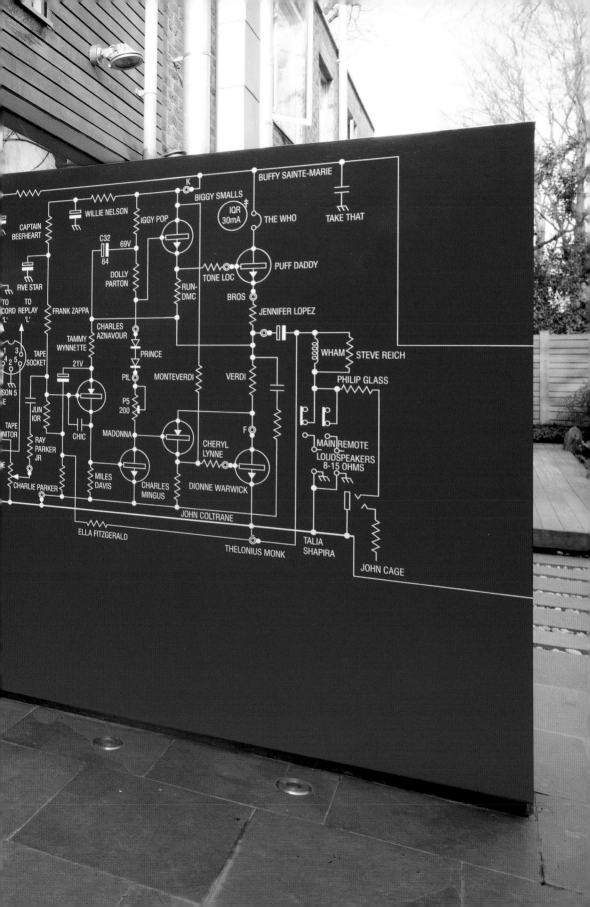

previous spread
and opposite:
Ohm Sweet Ohm, 2000
Wall drawing
vxo House, Hampstead,
London

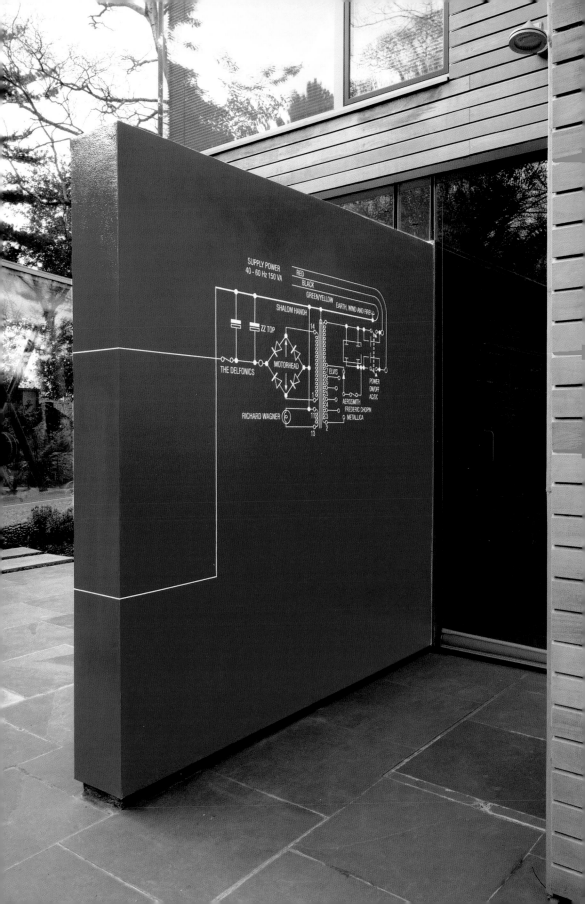

previous spread, foreground:
*Framework for Colour
Co-ordinating and Building
Purposes, (House of Stuart),*
1992 (with Douglas Gordon)
Installation view: *A Modest
Proposal*, Milch Gallery,
Great Russell St., London

below:
*Colours for Identification,
Coding and Special Purposes,*
1992 (with Douglas Gordon)
(detail)
Project for *Frieze* magazine

opposite:
*Framework for Colour
Co-ordinating and Building
Purposes, (House of Windsor),*
1992 (with Douglas Gordon)
Installation view: *A Modest
Proposal*, Milch Gallery,
Great Russell St., London

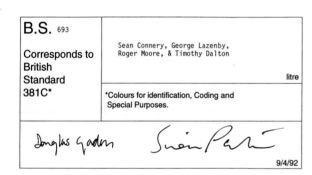

B.S. 693

Corresponds to
British
Standard
381C*

Sean Connery, George Lazenby,
Roger Moore, & Timothy Dalton

litre

*Colours for identification, Coding and
Special Purposes.

9/4/92

B.S. 539

Corresponds to
British
Standard
381C*

Mantegna

litre

*Colours for identification, Coding and
Special Purposes.

9/4/92

Broadsword
Calling Danny Boy

Michael Archer

Three sets of dinghy sails – mainsail and jib – are hoisted. The masts that hold them are attached not to boat hulls, but to simple, cross-shaped tubular stands. They won't go anywhere, but then they're inside the gallery, so there is no wind anyway. Like all dinghy sails they have markings on them – a class mark and a number. Though the sets of sails are of the same pattern and size, these marks are all different, and they're not the kind familiar in any club fleet. The classes are R, C and L, and under each of these we read a name – Raymond Chandler, Currer Bell and Laurence Sterne respectively. The numbers are the dates of their births and deaths. Where to begin with this work, *Untitled (Sails)*? The names are all those of authors, and are a diverse bunch at that. Chandler and Sterne are well enough known, even if we haven't actually read *The Life and Opinions of Tristram Shandy*, and only know Philip Marlowe from films. Currer Bell is more of a problem, unless we know that C, as well as standing for Currer, could equally stand for Charlotte (Brontë), who used it as a pseudonym in order to get herself published. If it could be Charlotte instead of Currer, why not Brontë instead of Bell? Of course not, because then the names would not form a coherent group referring to boats and sailing – the ship's chandler, responsible for parts and supplies, the bell to sound the watch, and the stern(e) that is both the part of the boat from

below:
Rout #2, 1992 (detail)
Wall drawing

opposite:
*The Last Supper Arranged
According to the Flat Back
Four Formation (Jesus Christ
in Goal)*, 1990
Wall drawing
Installation view: Aperto,
Venice Biennale 1993

which one can see how far one has travelled, and the stars by which one steers. There is a mixing of material and language here that is often encountered in Simon Patterson's work. It seems at first that what might have happened is that information from one sphere has been brought into contact with material from another in order to make a new, third reality. In truth, though, it is impossible really to separate those distinct territories. Sailing and literature can't be kept apart, because the play in one both matches and forms a constituent part of play in the other. Speaking of the work at the time it was made, Patterson said that one of the things going through his mind was the artist's perennial problem of

the blank canvas. This takes us both back to Sterne, who was quite content to leave chapters of Tristram Shandy in which nothing happens as blank pages, and in the direction of the Minimalist and Conceptualist predecessors whose work is frequently alluded to by Patterson.[1]

Patterson names things. Which is to say, he gives names to things that already have names. When confronted by name and thing, or name and image, or name and sign, the link can appear to us obvious, straightforward, complex, obscure, amusing, hilarious, idiosyncratic, capricious, provocative, or much else. But while we may acknowledge that chance has played

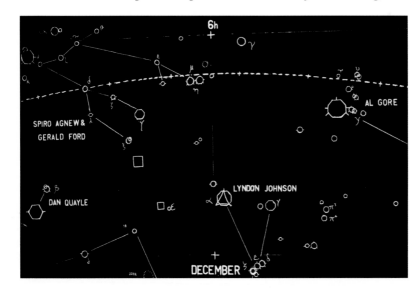

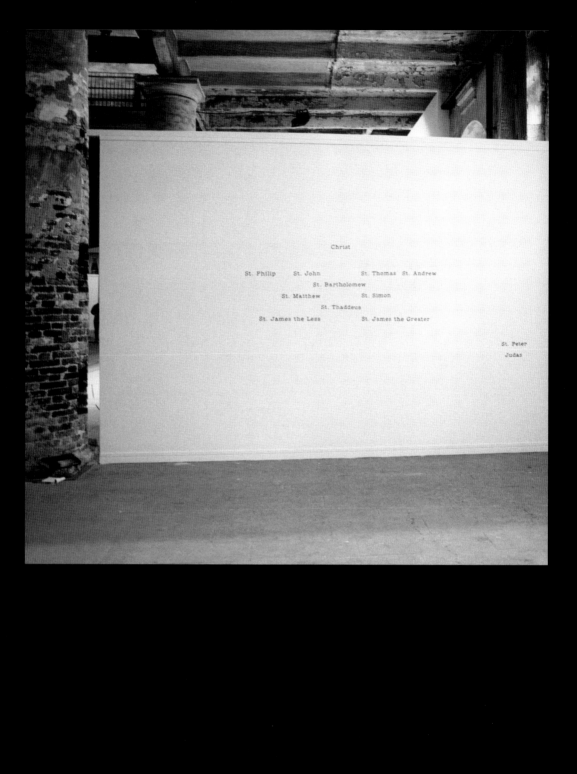

Christ

St. Peter

St. John		St. Philip
St. Thaddeus		St. Bartholomew
St. Andrew	Judas	St. Simon
St. Thomas		St. Matthew

St. James the Less
St. James the Greater

its part in forging the connection, it is hard
to think of it as in any way arbitrary. His wall
drawings of the Last Supper, for instance,
in which Jesus and the twelve disciples
are disposed as a football team plus two
substitutes arranged according to either
the sweeper or flat-back-four system, date
from 1990. That year the world cup was
staged in Leonardo da Vinci's home country,
Italy. And in *Roadworks*, a F1 starting grid
and finishing line painted on an ordinary
main road, Patterson toyed with the idle
fantasies of so many callow youths who sit
behind the wheel. The starting grid was
positioned just before some traffic lights in
the centre of the French town of Givors, as
if to mock the widespread urge to get away
quicker than the car alongside you, and
the finishing line, marked ARRIVEE, was
placed just at the point where the town's
speed restriction finished. Patterson's
connections reveal to us that any name, all
names, draw their denotative power from
the system of which they form a part. That
we indicate the element copper with the
letters Cu, for example, reinforces, each time
we use it, the cultural significance of Latin –
linguistically, historically, intellectually,
politically, and theologically as much as
scientifically. But then in *I Quattro Formaggi II*,
a representation of the Periodic Table,
Patterson says that Cu is the symbol for

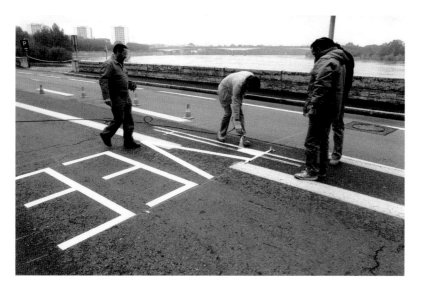

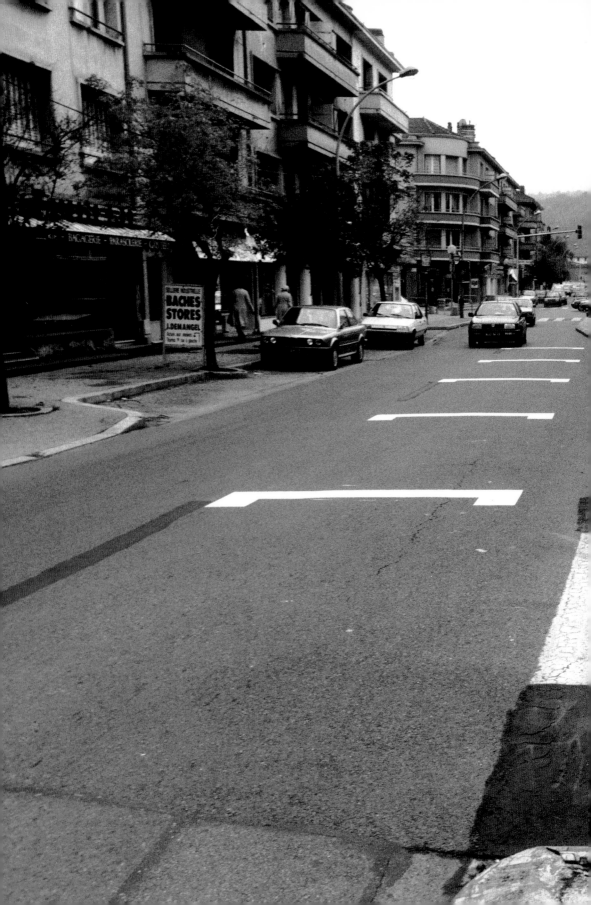

Cu

John Thaw

John Thaw. Cu = copper = policeman = Jack Regan and/or Morse as played by John Thaw in the TV series 'The Sweeney' and 'Inspector Morse'. This kind of word play is typical of the way in which material is identified in Patterson's work. Far from being self-consciously smart it is, rather, indicative of the inescapably multivalent nature of all language. Copper is both a highly conductive metal and a policeman. The double meaning lies embedded within the word itself. What Patterson does is to point to the ambiguity and in doing so to ask whether we don't, in habitually choosing to overlook that familiar fact for the sake of communicational clarity, sometimes treat language and ideas as more solid and durable than they actually are. J.L. Austin's notion of the 'performative' statement, which is to say, a statement such as naming that, through its utterance, accomplishes an action, is close to what we are talking about here. This type of utterance is not, as Austin assures us, merely 'a type of nonsense'. It belongs, rather, to a class of statements he calls 'the masqueraders'. While they may appear as straightforward statements of fact they are actually 'either (in interesting non-grammatical ways) nonsensical or else intended as something quite different'.[2] In Patterson's case the disarming directness of his processes of naming impresses upon us the degree to which his art has

to do with heightening our awareness of the weave and texture of contemporary life.

From the lists he compiles, and from the names that appear - often more than once - in his works, we can infer something of Patterson's predilections. He likes Westerns, Adventure and Action films, Kung Fu, and British comedies; he watches a prodigious amount of television, cop shows and sitcoms as much as news and current affairs programmes; he has a wide historical knowledge; he listens to music and reads a lot; he is keen on sport, particularly football and Formula One motor racing. Such a description, far from suggesting that he is exceptional, indicates that he is pretty much like many other people. Which is to say, also, that it doesn't really tell us much about him as a person, because that isn't ever the point. The names he uses, then, are part of the landscape we all inhabit, and where he goes further than most of us might - he knows the names of all the Russian cosmonauts and all the US astronauts, he knows all the teams, past and present, that have ever played in the Scottish league, etc., etc. - this assiduous completism is also a familiar phenomenon. It is part of a recognisable behaviour pattern in a modern world in which, even if we don't actually know everything, we somehow feel that any knowledge, when required, is immediately and readily accessible to us. It's not the case, of course;

Ronald Reagan
Donald Regan

Bette Davis
Miles Davis
Windsor Davies

Douglas Fairbanks sr.
Douglas Fairbanks jr.
Douglas Bader
Douglas MacArthur
Kirk Douglas

Michael Caine
Marti Caine
Marty Feldman

Burt Lancaster
Burt Reynolds
Debbie Reynolds

Benedict Arnold
Arnold Swarzenegger
Kurt Waldheim

Sean Connery
er

Roger Moore
Timothy Dalton

Tommy Cooper
Henry Cooper
Ronnie Corbett
Steve Cram
Thomas Cromwell
e.e. cummings
Gottfried Daimler
Charles Darwin
Roger Daltrey
Olivia de Havilland
Eamonn de Valera
Claude Debussy
Dieter Degowski
Len Deighton
Andrea Del Sarto

Delacroix
Piero Di Cosimo
Giovanni Di Paulo
Charles Dickens
Angie Dickinson
Benjamin Disraeli
Admiral Karl Doenitz
Bob Dole
John Donne
Dostoyevsky
Michael Douglas
Kirk Douglas
Sir Arthur Conan Doyle
Captain Alfred Dreyfus
Faye Dunaway

Republicans, 1989
Artists book, published by
Third Eye Centre, Glasgow,
Arefin Inc. and the artist

at least, not in any substantially useful or productive way. But it appears so, and giving the lie to that apparent simplicity in what at the same time seems such an effortless manner, is Patterson's strength. 'Natural history,' says Michel Foucault, 'is nothing more than the nomination of the visible. Hence its apparent simplicity, and that air of naiveté it has from a distance so simple does it appear and so obviously imposed by things themselves.'[3] Something very similar holds true for Patterson's art.

In the monograph on his work published in 2002, Patterson groups his works according to the categories of animals listed in the short story, 'The Analytical Language of John Wilkins', by Jorge Luis Borges. The list is famously referred to by Foucault as the stimulus for his own book, *The Order of Things*, a work that examines the conditions under which certain systematic bodies of knowledge – natural history, grammar, the analysis of wealth – become possible, and further considers the circumstances in which these are subsequently transformed into biology, philology and political economy. As Bernard Fibicher reminds us, Foucault asks what context might exist in which the categories enumerated in Borges's fictitious Chinese encyclopaedia could co-exist?[4] To put creatures classifiable as 'sirens', 'stray dogs', 'frenzied', or 'having just broken the water

pitcher' side-by-side is one thing, but when one of the categories is 'included in the present classification', this introduces an impossible conundrum: a category among others that nonetheless subsumes all the others. There is no place the mind can conceive in which such a conundrum becomes soluble. We might wish to define these odd juxtapositions as surreal, but even the Comte de Lautréamont's classic surrealist encounter between the sewing machine and the umbrella took place upon the firm platform of the operating table. Borges has removed the table, so that the only place left to us is the space of language itself. There is, nonetheless, something in Patterson's work that connects with surrealism, especially to André Breton's idea of poetic analogy:

> Poetic analogy has this in common with mystical analogy: it transgresses the rules of deduction to let the mind apprehend the interdependence of two objects of thought located on different planes. Logical thinking is incapable of establishing such a connection, which it deems a priori impossible. Poetic analogy is fundamentally different from mystical analogy in that it in no way presupposes the existence of an invisible universe that, from beyond the veil of the visible world, is trying to reveal itself.[5]

Such analogy, as Breton argues, is what fascinates and gives us 'access to the motor of the world'.

General Assembly is an arena. Made in 1994 its prime reference is to the football match organised in the Sarajevo stadium between soldiers from the UN peacekeeping forces then stationed in Bosnia, and players from the local football team. The work occupies an entire room, turning it into an echo of the Sarajevo stadium. On one wall are several rows of metal brackets to the ends of which are fastened wooden 'seats' painted a sky blue. Though the rows of brackets are raked, in the same way as the seating in a grandstand would be, the presence on each seat of a letter, and the addition on the lowest level of a long 'bench', marks this as an oversize typewriter keyboard. The top row is numbers and symbols, the second QUERTYUIOP, and so on, down to the space bar. A single red seat at the right hand end of the third row marks the tab key. On the walls adjacent to this bleachers-cum-typewriter are single rows of similar seats, the letters on which spell out the sentence well-known to all who have ever learnt to type: 'the quick brown fox jumps over the lazy dog'. All letters of the alphabet used in quick succession – comprehensiveness, totality, universality. (The font used by Patterson for the lettering is Univers as well.) There are names on the wall above several of the seat brackets. Some are real countries and some the names of lands described by Jonathan Swift in *Gulliver's Travels*. There, too, are Dag Hammarskjöld, Kurt Waldheim, U Thant, Javier Perez de Cuellar

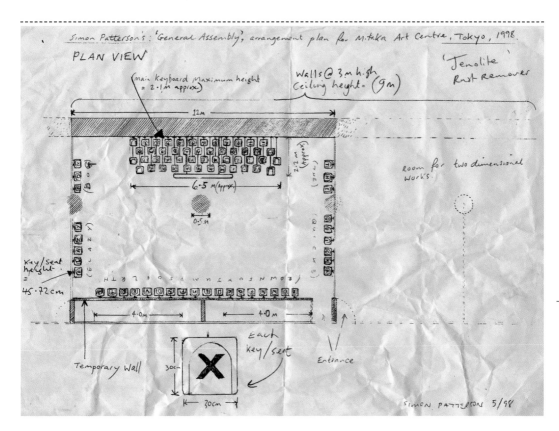

above:
General Assembly
arrangement for Mitaka Art
Center, Tokyo, 1998

and Mr. Boutros-Boutros Gali, five Secretary Generals of the United Nations. These names indicate that the reason for the presence of the five real countries – France, China, United States, Russia and Great Britain – is that they are the permanent members of the UN Security Council. So while some lands are real and others imaginary, all refer to the dissonance between our idealised perception of humanity's potential, and the continual process of negotiation and compromise needed to sustain interpersonal relationships in the face of human error and frailty.

As Patricia Bickers has pointed out, one important aspect of the manner in which *General Assembly* generates its effect as a work of art is the way its form bears upon the 'question' of sculpture.[6] The entire work is wall-mounted, yet its allusion to the sports arena animates the gallery floor as a site of action. It extends, in any case, out into the room, breaking from the flat, two-dimensional vertical surface into the three dimensions of real space. It also positions the viewer 'on the pitch' as it were, reversing the position of onlooker and participant. And the fact of this reversal is brought home all the stronger by the perception that, while the 'keys' are also 'seats', and thus designed to be sat on, they will not, in reality, quite support anyone who tries to use them in that way. They remain resolutely things to be

Rhodes Reason

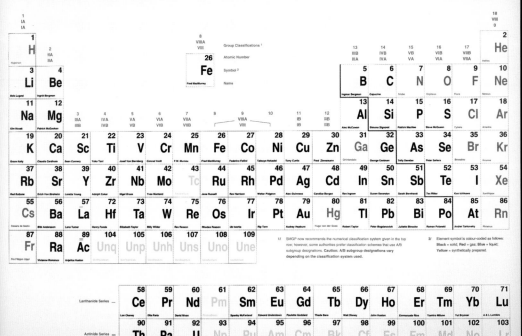

opposite:
Rhodes Reason, 1995
Silkscreen print

right:
Rex Reason, 1994
Artist's book
Published by Bookworks

36

37

Kr

Rb

Kronos

Red Buttons

looked at, a status that calls up the various theoretical pronouncements about the 'theatricality' of 60s minimalism.

It is conceivable that *General Assembly* could be updated by adding the name Kofi Annan to those others on the wall. To do so, however, would be to impose the more recent debates about the efficacy of the UN, and the circumstances that gave rise to those debates, upon the original situation to which the work alludes. It would be, in other words, to make a new work that does not have the internal structural consistency of the original. The seats/typewriter keys echo those of the portable model designed by Ettore Sottsass for Olivetti. Patterson, at the time, used such a model himself. Now he uses a computer like the rest of us, a piece of equipment for which he has also now made work, such as the screen saver in his *Colour Match* series.

In the same year as *General Assembly*, Patterson published *Rex Reason*, a book that devotes a page to the symbol for each element of the periodic table from Hydrogen (H), atomic number 1, to Unnilseptium (Uns), atomic number 107 along with a name suggested by the symbol in one way or another. For instance Iron, Fe, atomic number 26, is Fred McMurray. And if that seems to be stretching a point somewhat, then its successor on the facing page, Cobalt, Co, atomic number 27, is Federico Fellini. The symbols are colour coded according to the

state of the designated element under normal conditions: solids appear in black, liquids in blue, gases in red, and those that do not naturally occur in yellow. These divisions are reinforced by the names Patterson gives to them. Solids are film actors and directors, gases characters from Greek mythology, and liquids a range of figures from the arts and sciences. The synthetic elements, already artificial and without exception transitory due to their radioactive nature, are given their own names, though there is an exception that proves this rule. Berkelium, Bk, atomic number 97, is called Bilkolium. In one respect the intrusion of Phil Silvers' celebrated quartermaster sergeant with an eye to the main chance into this synthetic landscape merely doubles the madcap futility of the situation. All that knowledge, all that money, all that high-tech equipment used to generate a few atoms of an otherwise non-existent substance, only for them to decay within fractions of a second into something else. In another respect, the intrusion of Patterson's boyhood TV viewing habits serves to sustain a link made in an earlier work that also used the periodic table. *I Quattro Formaggi II* (1992) is a wall of tiles, each of which is again printed with the symbol for one of the elements together with a suggestion by Patterson as to what that symbol denotes. His suggestions, however removed they may be from the

idea space indicated by the table, play intimately with the linguistic possibilities presented by the letters. Hydrogen (H) is Edward Teller, a straightforward reference to the development of nuclear weaponry. But here, as so often, we find a mixture of references to myriad fields of human endeavour. Not only scientists, but also politicians, characters from mythology, religious leaders, painters, poets, film stars, singers, musicians, writers, fictitious figures, and more. And all within a work that takes its title from a kind of pizza. Berkelium here is Steve Biko.

There are, of course, constant developments in the field of chemistry, and thus when Patterson used the table again in 1995 for the series *24 Hours*, it listed 109 elements. *24 Hours* comprises 24 images of the table, each silkscreened onto a separate canvas. As with *Rex Reason*, solids, liquids, gases and synthetics are differentiated by the black/red/yellow/blue colour code, the two dozen versions being generated by working through all possible combinations of those colours (1 x 2 x 3 x 4 = 24). Throughout the years in which he explored the possibilities inherent within the periodic table, Patterson was well aware of the earlier use Carl Andre had made of it. He had put it, for example, on the mailing card for an exhibition at the Lisson Gallery in the early 1970s, the same gallery that now represents Patterson. His own

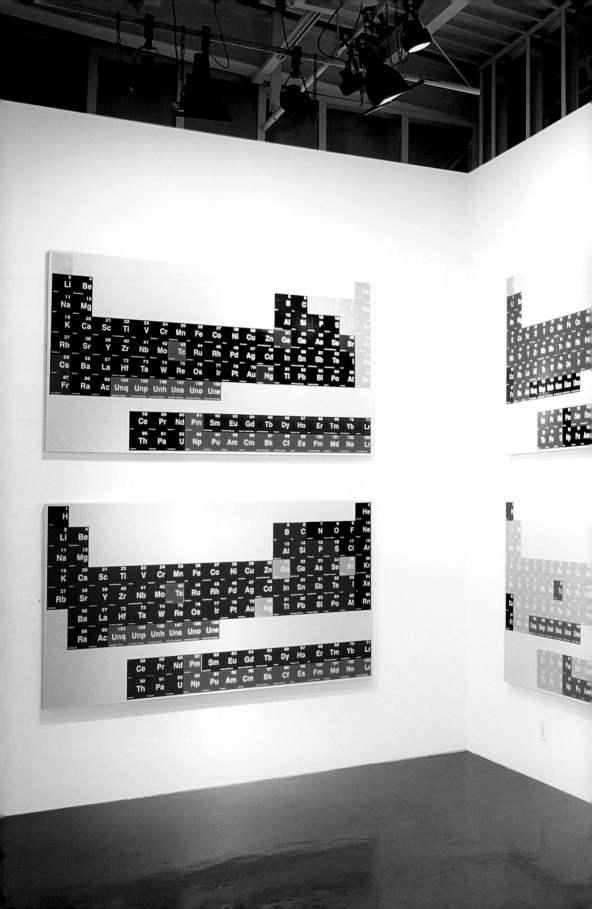

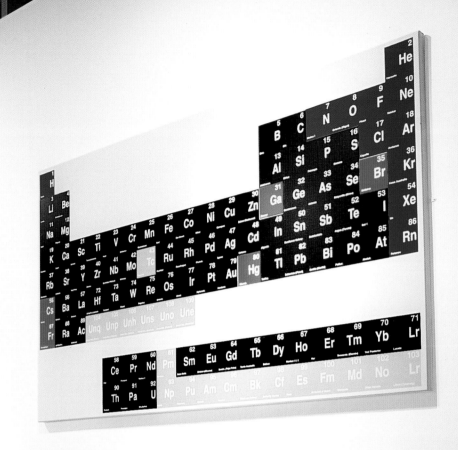

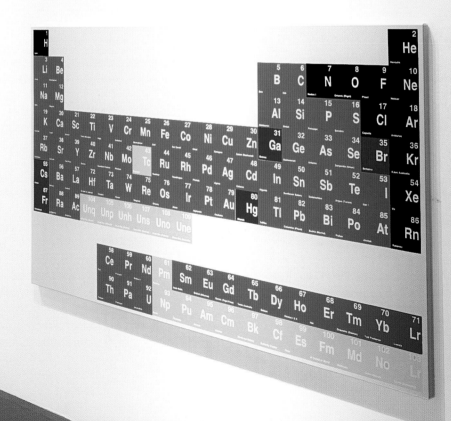

opposite:
JP233 in c.s.o. Blue, 1992
Wall drawing
Installation view: Kunsthalle,
Wien

overleaf:
JP233 in c.s.o. Blue, 1992
(detail)

decision to use it, therefore, is a deliberate
gesture towards minimalism as an influential
formal and theoretical resource. Similarly,
the use in *24 Hours* of the primary colours
with black, and their appearance in all
permutations, makes reference to the
conceptualism of Sol LeWitt. More generally,
LeWitt's development of the wall drawing
as a viable artistic form is crucial for
Patterson's practice.

Patterson's work is not political in the sense
of its adopting a position on current affairs.
It is more that his interest in language insofar
as it reveals the rationale behind accepted
systems and structures can't help but lead us
to ponder the implications of what surrounds
us in the world. The wall drawing *JP233 in
c.s.o. Blue* is an obvious case in point. Made
at the time of the first Gulf War, the title
refers to a bomb designed to put runways
out of action (JP233) and the background
colour (c.s.o. Blue) used in film and TV studios
to facilitate superimposition of a figure over
a different background. The equivalence
drawn by the title between weaponry and
the media is the same as that addressed
by Jean Baudrillard at the time:

> So this military 'orgy' wasn't an orgy at all. It was
> an orgy of simulation, the simulation of an orgy.
> A German word sums all this up very well:
> Schwindel, which means both giddiness and
> swindle, loss of consciousness and mystification.
> The Americans fought the same war in respect

of world opinion – via the media, censorship, CNN,
etc. – as they fought on the battlefield. They used
the same 'fuel air' explosives in the media, where
they draw all the oxygen out of public opinion.[7]

The image of *JP233 in c.s.o. Blue* is a map
showing the range of services provided
by Delta Airlines, the airports it serves
being renamed. With some the alteration
is slight – Orlando, for instance, becoming
Orlando Gibbons. Sometimes, indeed, there
appears to be no change at all – Washington
remains Washington, and New York is
John F. Kennedy – but because so much else
around them changes, it is hard not to see
them also in a new light. Pittsburgh is
William Pitt, and he, along with a smattering
of military figures from the 18th century,
brings the question of Anglo-American
relationships to the fore. Once we see this,
the fact that London has become JP233
makes perfect sense as a mark of Britain's
role as a glorified US 'aircraft carrier'. Glenda
Jackson is near Ken Russell, in a nod towards
their work together on *Women in Love*, and
by dint of sharing a surname she is also near
Jesse Jackson. This simple transition from
a British actor who by that time had already
changed her profession to that of politician,
to an American preacher politician is, though,
not enough. There is an unvoiced 'third'
Jackson lurking in between them. Two
nearby airports have been called Martin
Shaw and Lewis Collins, alerting us to the

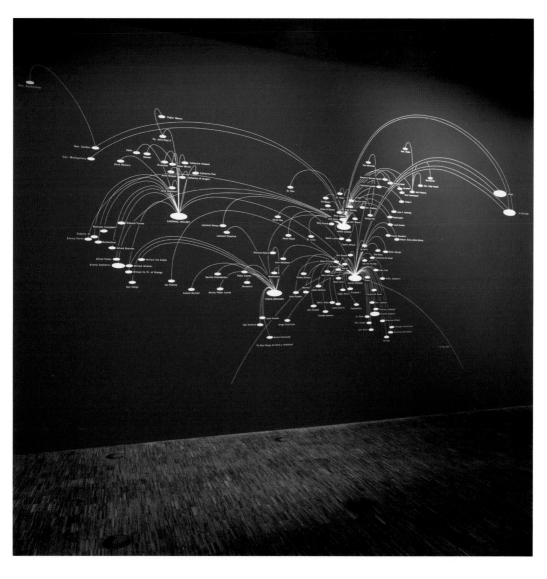

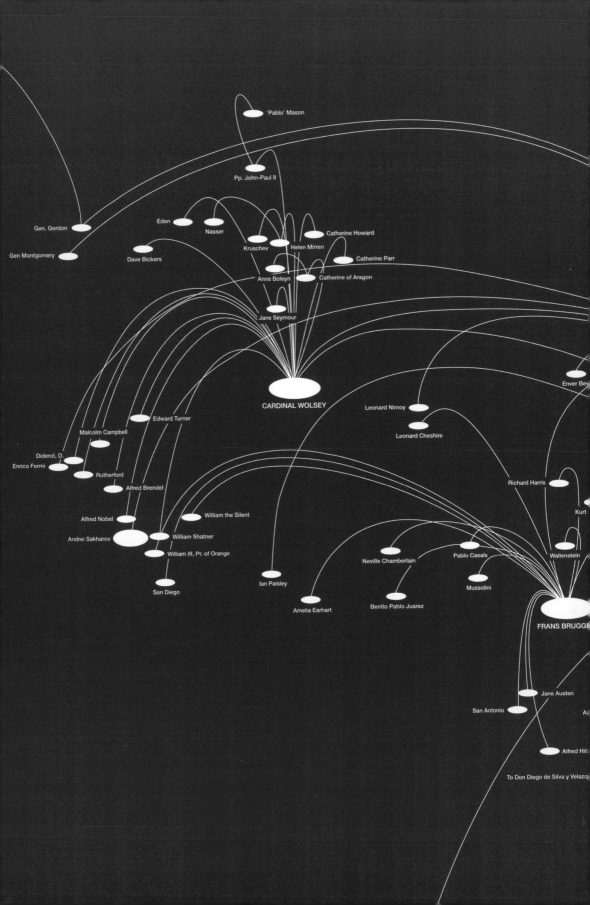

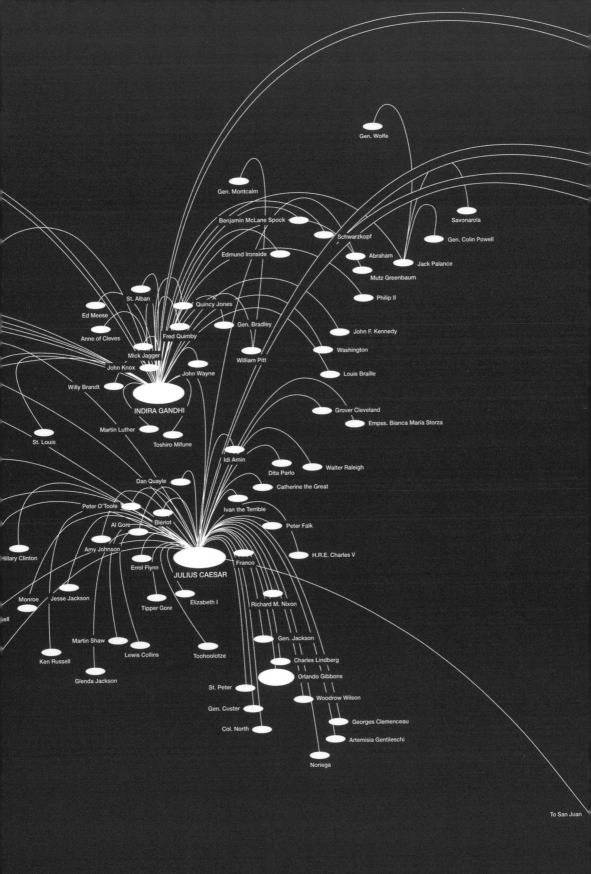

Gen. Wolfe

Gen. Montcalm

Benjamin McLane Spock

Savonarola

Schwarzkopf

Gen. Colin Powell

Edmund Ironside

Abraham

Jack Palance

Mutz Greenbaum

Philip II

St. Alban

Quincy Jones

Ed Meese

Gen. Bradley

John F. Kennedy

Anne of Cleves

Fred Quimby

Washington

Mick Jagger

John Knox

William Pitt

Louis Braille

John Wayne

Willy Brandt

INDIRA GANDHI

Grover Cleveland

Martin Luther

Empss. Bianca Maria Storza

St. Louis

Toshiro Mifune

Idi Amin

Walter Raleigh

Dita Parlo

Dan Quayle

Catherine the Great

Peter O'Toole

Ivan the Terrible

Al Gore

Blériot

Peter Falk

Amy Johnson

Hillary Clinton

H.R.E. Charles V

Errol Flynn

Franco

JULIUS CAESAR

Monroe

Jesse Jackson

Elizabeth I

Richard M. Nixon

Tipper Gore

Martin Shaw

Gen. Jackson

Ken Russell

Lewis Collins

Toohoolotze

Charles Lindberg

Glenda Jackson

Orlando Gibbons

St. Peter

Woodrow Wilson

Gen. Custer

Georges Clemenceau

Col. North

Artemisia Gentileschi

Noriega

To San Juan

62

fact that the person Patterson may well really be thinking about is Gordon Jackson, who plays Bodie and Doyle's c.1.5 boss in *The Professionals*. What is also key to this work, I think, is the graphic style of the original map of American air routes. With the removal of all outlines of the American and European land masses what is left is a collection of elliptical blobs linked by sprays of gracefully arcing lines. More than anything they remind one of the wells left spewing oil by the retreating Iraqi army at the end of the war.

Warfare, too, lies at the heart of *Landskip*. Patterson's choice of spelling here introduces a particular historical focus. First staged in 2000 in the grounds of Compton Verney, an estate with a Robert Adam house whose gardens and park were designed by Lancelot 'Capability' Brown in the 1760s, we are being asked once more to reflect on the ideals and precepts embodied in that environment at the time of its creation. The conscious – and self-conscious – modelling of gardens and parkland, and the establishing of views that, between them, represent the beautiful, the picturesque and the sublime, within an overall recreation of 'classical' nature is being recalled. Nature is remade into an Arcadian idyll. In his *Discourses*, delivered to students at the newly established Royal Academy from 1769 onwards, Joshua Reynolds uses several different spellings of the word. Sometimes landscape, it is also

at times written as 'landschape', and at others 'landskip'. Such inconsistencies appeal to Patterson. Luggnagg appears twice in *General Assembly*, once under that spelling, and once as Lugnagg. It originally occurred thus because of a mistake and what was thought to be a spelling error. On checking, though, Patterson discovered that Swift himself used both versions of the word, writing as he was before the convention of fixed spellings became established. While on the face of it, such inconsistencies first strike one as oversights, they are often, in true Freudian terms, slips full of meaning.[8]

Gardening, as far as Gardening is an Art, or entitled to that appellation, is a deviation from nature; for if the true taste consists, as many hold, in banishing every appearance of Art, or any traces of the footsteps of man, it would then be no longer a Garden. Even though we define it, 'Nature to advantage dress'd,' and in some sense it is such, and much more beautiful and commodious for the recreation of man; it is however, when so dress'd, no longer a subject for the pencil of the Landskip-Painter, as all Landskip-Painters know, who love to have recourse to Nature herself, and to dress her according to the principles of their own Art; which are far different from those of Gardening, even when conducted according to the most approved principles, and such as a Landskip-Painter himself would adopt in the disposition of his own grounds, for his own private satisfaction.'[9]

opposite:
*Richard Burton/Elizabeth
Taylor*, 1988
Silkscreen on acrylic gesso
on canvas
Installation view: *Freeze*, 1988

right:
Freud/Rorschach/Jung,
1998
Silkscreen on acrylic gesso
on canvas

Freud Rorschach Jung

65

In the same year that he began delivering
his *Discourses*, Reynolds showed Dr Johnson
his double portrait of Mrs Bouverie and
Mrs Crewe sitting in front of a tombstone.[10]
In reply to Dr Johnson's expression of
puzzlement over the apparently
inconsequential inscription on the tomb,
Reynolds suggested that he ask the king,
George III, who had had no difficulty in
understanding it the previous day. Where
Johnson had read simply 'I am in Arcadia',
the king had recognised immediately that
Et in Arcadia Ego implied that even in the lush
and plentiful surroundings of this Utopian
scene, death lurks. Erwin Panofsky has
famously written about this, identifying
Virgil as the first to articulate the irresolvable
tension implicit within the phrase:

> In Virgil's ideal Arcady human suffering and
> super-humanly perfect surroundings create
> a dissonance. This dissonance, once felt, had to
> be resolved, and it was resolved in that vespertinal
> mixture of sadness and tranquillity which is
> perhaps Virgil's most personal contribution to
> poetry. With only slight exaggeration one might
> say that he 'discovered' the evening.[11]

Patterson's *Landskip* involves the periodic
letting off of various coloured smoke grenades
within Brown's parkland at Compton Verney.
The connection he is pointing us towards
is that between the rationale behind
the garden's origins, and the fact that,
during World War II, the grounds were

commandeered by the army for camouflage
training. We see death hiding behind the
green, purple, yellow, white, red and blue
smokescreens, and we think of the close
relationship between modern art and warfare
in, for example, the dazzle camouflage used
on warships in World War I.

Patterson's own double portraits are
somewhat stark. *Richard Burton/Elizabeth
Taylor* is two panels, each bearing one
of the stars' names. In the three decades
that have elapsed since Conceptualism, we
have, though, become adept at discerning
the subtleties and complexities in such
ostensibly straightforward statements.
The proportions of the canvases would
most usually be described as portrait
format. Regardless of what appears on them,
therefore, it is accepted that they represent
people. The black lettering of the names,
Richard Burton and Elizabeth Taylor, is
not painted, but silkscreened onto the white
ground, a process that constitutes a double
reference to Andy Warhol. It reproduces
the production method of Warhol's own
portraits, and in doing so focuses on the
mechanisms of celebrity and notoriety that
preoccupied the Pop artist. Furthermore,
Patterson's choice of the typewriter font
signals a documentary detachment and/or
a journalistic objectivity that allows viewers
to project their own knowledge of, and
attitudes and feelings towards the married,

divorced and remarried couple into the representational space of the work.[12]

Richard Burton/Elizabeth Taylor is significant as an early expression of Patterson's absorbing interest in film – not film as fine art, not something to be discussed according to auteur theory or whatever else, but film as the cornerstone of our mainstream cultural experience. The films to which he makes reference are the ones we have all seen – perhaps at the cinema when they first came out, but certainly on television a hundred times since. Burton appears again in *Where Doubles Dare*, made for an exhibition in Bregenz, Austria, in 1998. Seizing on the fortuitous fact that the film *Where Eagles*

Dare was filmed not far away, Patterson fixed name-plates to the roofs of the gondolas on the nearby cable car, calling one Richard Burton and the other Clint Eastwood – the two 'heroes' of the film. Thus signed, the cars recall the location for the gripping confrontation between Burton and the 'baddie' played by Peter Barkworth, and because they were so central to the plot of the movie they could almost be thought of as characters themselves.

A trio of paintings from 1998 name Yves Klein, Enzo Ferrari and Miles Davis. Like Ad Reinhardt's black paintings which, as we stand before them for any length of time, radiate the primary colours underlying the

left:
Shane, 1997
Wall drawing
Installation view:
Kunsthaus, Zurich

opposite:
Bad Day at Black Rock, 1998
Acrylic on canvas
Collection Dina and Edwin
Wulfsohn, London

68

nuanced tonal distinctions between the different areas of the surface pattern, these black names on their white grounds become three resplendent monochromes as we think of Klein's International Klein blue, the bright red Formula One cars beloved of the *tifosi*, and Davis's celebration of blackness through his music. The monochrome and, more generally, American colour field painting are also strongly in evidence in Patterson's large-scale works on the subject of film. These have been made in a variety of media – some lightbox-mounted prints, some wall drawings, and others acrylic on canvas. On grounds that mimic the formats of wide-screen film technology, and which play the riches of colour stock off against the tonal subtleties of black and white, Patterson places the names of various films' leading stars. *Bad Day at Black Rock* is a wide strip containing a grid of coloured blocks ranging through the visible spectrum into whites, blacks and greys – in other words, the standard Kodak printing reference of colour patches and grey scales. Spencer Tracy sits at the left hand, colour, end of this strip and Robert Ryan to the right. Placed as he therefore is over the black and white part of the grid his name carries a faint echo of the similarly named painter of white paintings, Robert Ryman. Other works take their inspiration from Akira Kurosawa's Samurai films, works inspired by the American Western genre that, in their

turn, influenced Sergio Leone's Spaghetti Westerns. Patterson acknowledges these, too, as in the lightbox-mounted *Western: The Good the Bad and the Ugly*. In these last two instances and in *High and Wide*, a skewed reference to John Wayne's *The High and the Mighty*, the names are vertically elongated suggesting the curious distortions required – and that are especially noticeable during the credit sequence – for films shot in wide-screen formats to be fitted into what until recently was the standard 4:3 TV screen ratio. In contrast, another lightbox piece, *Western: High Plains Drifter*, has the blocks of colour stretched vertically while Clint Eastwood's name is squat and wide. Eastwood's first film as director has its own fun with names, one of the headstones in the town's graveyard being dedicated to S. Leone. It also, of course, has a scene in which Eastwood's 'Stranger' forces the inhabitants to paint their town entirely red prior to his renaming it 'Hell'. The intimations of all-encompassing dimensions imparted by the horizontal and vertical elongations, together with the inference of all-over redness introduces the idea of such paintings as Barnett Newman's *Vir Heroicus Sublimis*, a work he was insistent should be experienced not from a distance where it could be comfortably viewed in its entirety, but close enough for it to envelop the viewer.

Richard Burton/Elizabeth Taylor is the first of Patterson's name paintings. In ten or so

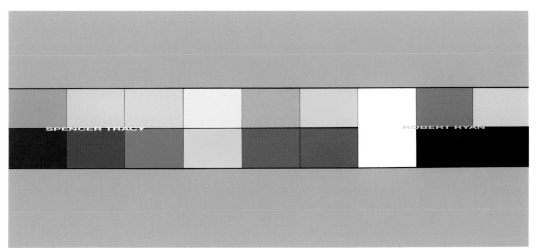

SPENCER TRACY

ROBERT RYAN

below:
Western: High Plains Drifter,
1998 (detail)
Cibaopal print in lightbox
Collection Jack and Sandy
Guthman, Chicago

opposite, top:
*Western: The Good the Bad
and the Ugly*, 1998 (detail)
Cibaopal print in lightbox
Collection Kent and Vicky
Logan, Denver

opposite, below:
High and Wide, 1998
Acrylic on canvas
Courtesy Lisson Gallery

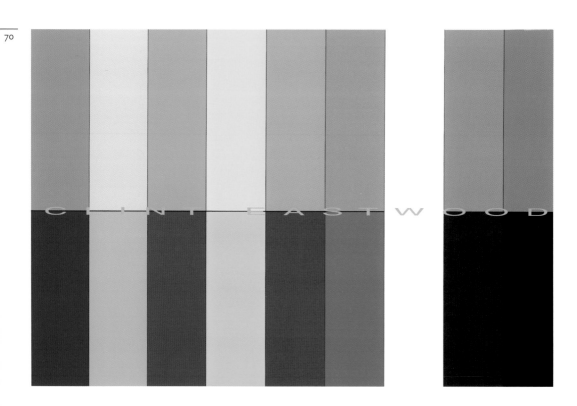

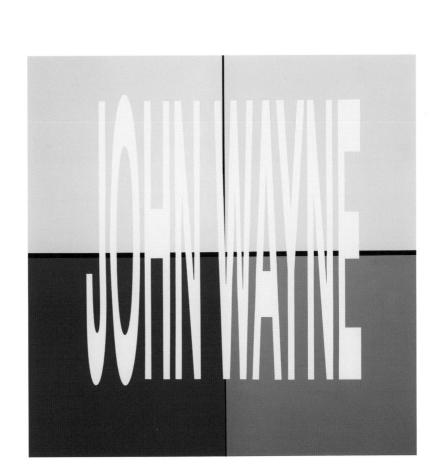

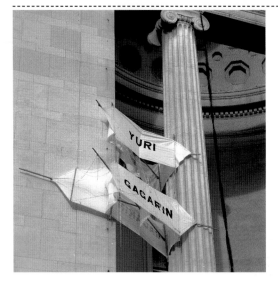

previous spread:
Enter the Dragon, 1999
Mixed media
Installation view:
Lisson Gallery at Kean Street, 2000

above:
Manned Flight, 1999–
Baskerville House,
Centenary Square,
Birmingham, 2000-01
Curated by Ikon Gallery

opposite:
The Great Bear, 1992
Four-colour lithographic print with aluminium frame

overleaf:
The Great Bear, 1992 (detail)

years following its appearance in 1987, he made some seventy more. Though in all cases the names are silkscreened in the same typewriter font, there is a huge range across the series. There are artists, including Matisse, Giacometti, Warhol, Beuys and Picasso. Are these admired precursors, inspirational models, influences, dutiful acknowledgements, or what? Then there are other figures from the arts, sciences and politics. Taken as a whole, perhaps, these names offer a counterpoint to Gerhard Richter's sequence of *48 Portraits*. In Richter's case, however, the 48 famous men are deliberately chosen in such a way as not to imply the espousal of any particular set of values or predilections. They are also all part of the one work, their collective presence contributing to the overall sense of anonymity and non-specificity Richter was aiming for. Patterson's choices are always much more pointed. His characters are very much his own constellation of key figures. A mark of this is that they recur in different works. Yuri Gagarin and Neil Armstrong are both allocated stations on the Explorers (District) Line in *The Great Bear*, Patterson's famous reworking of London Underground's 'Route Planner' map, and Gagarin features again in *Manned Flight, 1999-*, the ongoing work in which a heavy-duty kite capable of supporting a man, and bearing the cosmonaut's name, is positioned as if caught on its descent on

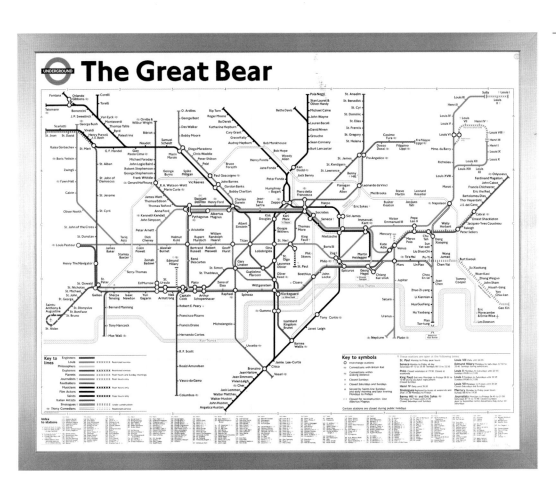

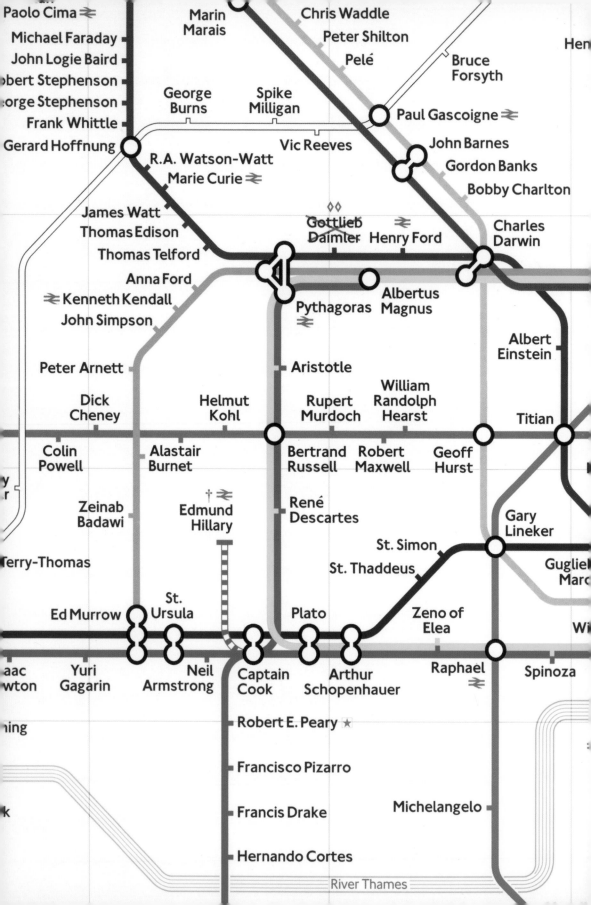

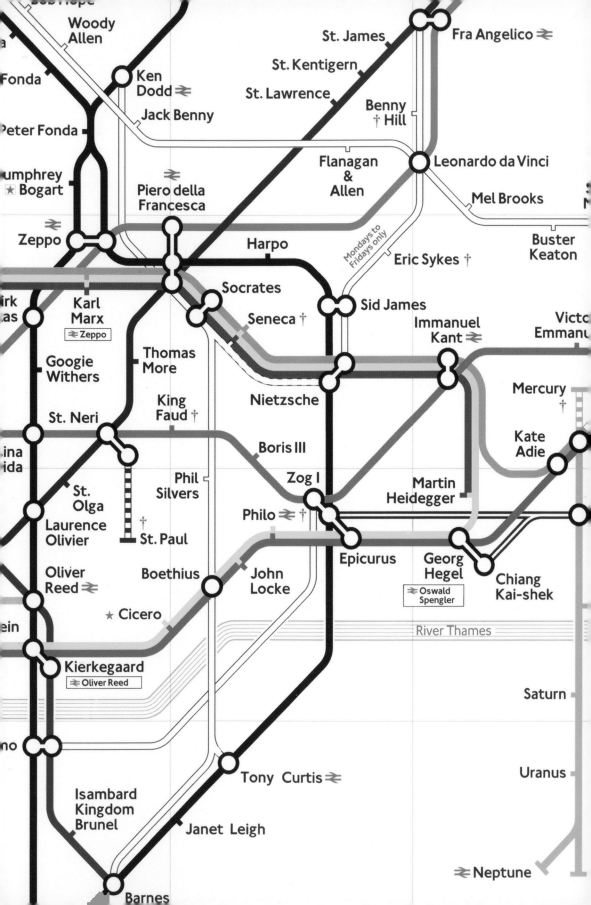

Tweedledum

Tweedledee

opposite:
Tweedledum/Tweedledee,
1993
Diptych
Silkscreen on gesso
on canvas

right:
Galilei, Galileo, 1993
Pythagoras, 1993
Albert Einstein, 1993
All silkscreen on gesso
on canvas

each occasion of its exhibition – between the fluted pillars of a classical portico in Birmingham, up a tree in a London park, in a back yard in Seoul, The kite is doomed to these repeated snaggings unless and until Patterson gets the opportunity to install it at the place outside Moscow at which Gagarin crashed his MIG-15 in 1968 while on a training flight. Once there, it will have finished its wanderings and the work will be complete. And in reaching Moscow it will have reconnected not only with the cosmonaut/explorer Gagarin, but also with the spirit of Suprematism, that equally exploratory tendency of the Revolutionary period. 'I call the additional element of Suprematism the Suprematist straight line (dynamic in character),' wrote Kasimir Malevich in *The Non-Objective World*. 'The environment corresponding to this new culture has been produced by the latest achievements of technology, and especially of aviation, so that one could also refer to Suprematism as 'aeronautical'.'[13]

In 1993 Patterson did a series of scientists – Einstein, Newton, Galileo, Copernicus, Curie, Pythagoras. Do these form a self-contained group? In one sense, perhaps they might. They are all in their various ways associated with moments of radical change in the way we account for the world, the way we perceive and conceive of it. In the main these changes mark a movement from a mind set now judged somehow mystical towards a more properly scientific attitude towards the explanation of material things. They are the kind of changes that Thomas Kuhn termed 'paradigm shifts'. But there are connections that can be traced beyond this group to others of the name paintings. Marie Curie's discovery that helped the eye to dissolve the implacable solidity of material things could link to W.K. Röntgen, Svengali, Mata Hari, Morse, Helen Keller, Edward Lear and Harry Houdini to suggest an extended meditation on the nature of the work of art. Seductive, misleading, ambiguous as to meaning, mute, requiring us to look beneath its mere surface qualities to discern its true significance, impossible to pin down, and so on. The diptych *Tweedledum/Tweedledee* could fit in here, too: a single work made from two identical parts. What are we looking at once, and what twice? And is one part a copy of the other, or are they equivalent to, or the same as each other? There are shades here of Joseph Kosuth's *One and Three Chairs*, where none of the three elements – chair, photograph and dictionary definition – is able to assert itself as primary. All three, instead, exist within a set of mutually supportive relationships.

Harry Houdini is one of the keys to Patterson's art. Though he had already done diptychs, triptychs and a thirteen-part first version of *The Last Supper*, Harry Houdini was the first single canvas name painting he

completed in 1989. The following year the escapologist appeared again in *Untitled*, a string of names that, in its first installation, was written around the cornice of a room at London's Milch gallery. The sequence is a fantastical game of tennis-elbow-foot that takes us from Dynastic Egypt and Ancient Greece, through the Ottoman Empire, the Holy Roman Empire, the end of the British Empire, the Third Reich, and on up to the present day. On the way there are, inevitably with Patterson, excursions into film. Margaret Rutherford sits between the prophet Isaac and J.C. Bach above the chimney breast, and on one side of the window bay is the surreal sequence that moves from the former Taoseach Charles Haughey to his almost-homonym from the Carry On films via several other actors from the same series into whose midst, for some mischievous reason, Patterson has introduced a robust feminist anti-pornography campaigner: ... Charles Haughey, Barbara Windsor, Kenneth Williams, Andrea Dworkin, Sidney James, Charles Hawtrey The name placed right above the door in this sequence, the person best able to escape quickly, is Harry Houdini.

Patterson has called Houdini his alter ego, a relationship that is made explicit in the film *Escape Routine*. Based on the mandatory safety demonstrations given by cabin staff to passengers prior to every flight, the film

Harry Houdini

below:
Escape Routine Storyboard,
2005 (detail)

opposite:
Escape Routine, 2002
Production still

84

weaves the standard instructions on the whereabouts of the nearest exit and the usage of seat belts, oxygen masks and life-jackets, with descriptions and demonstrations of escape routines taken from Houdini's *Houdini on Magic*. When, half way through the film, a passenger insists on smoking, his cigarette is extinguished with the deft crack of a bullwhip wielded by one of the steward-escapologists. Done first in English and then Japanese, the English section is voiced by Dilly Barlow, doyenne of British TV documentary voiceover studios. The authenticity of the voice is relevant. We hear the same attention to verisimilitude in the three versions of *Colour Match*, in which football teams and scores in France, England and Scotland are 'matched' against HTML or Pantone colours. For those three works Patterson had his texts read by Eugène Saccomano, Tim Gudgin and John Cavanagh respectively, each being familiar as the voice of the Saturday afternoon football results in their own country. Gently but insistently, through the opening section of *Escape Routine*, Barlow gives us advice on how best to accomplish a number of tricks, and on how important it is to develop the appropriate attitude to one's work. Beginning as it does with advice on how best to respond to criticism of one's performance, it soon becomes clear that the excerpts from

Place the mask over your mouth and nose, like this, and breath normally.

Along with handcuffs and neck irons, there are special types of metal collars made to lock about a person's neck and from which escape is seemingly impossible.

PLEASE DO NOT REMOVE FROM AIRCRAFT

opposite:
Colour Match, 2001
Screensaver

right:
Color Match, 1997
Audio CD covers

Houdini's book chosen by Patterson apply equally well to art making:

> Never work to fool a magician. Always work to your audience. Walk right out onto the stage and tell your tale to your audience, and perhaps many will believe it. Well chosen remarks on topics of the day are always in order. If you believe your own claim to miracle-doing and are sincere in your work you are bound to succeed.

The English section ends with a staging of the trick in which the bullet fired from a gun appears to have been caught between the assistant's teeth. In the second half of the film the instructions are repeated in Japanese before the finale in which leading practitioner, Shahid Malik, escapes after being bound, bagged and suspended upside down in the middle of the stage. One of the great masqueraders of today performs in full view of the camera, and yet we still don't quite get to see just how he does what he does.

Notes
1. See Vol. IX chapters 18 & 19 of Laurence Sterne, *The Life and Opinions of Tristram Shandy*.
2. J.L. Austin, *How To Do Things With Words*, Oxford University Press, Oxford, 1975, pp.3–4. See also chapters VIII and IX for a discussion of the relationship between locutionary, illocutionary and perlocutionary acts – saying, accomplishing something in saying, and engendering consequences as a result of saying.
3. Michel Foucault, *The Order of Things: An Archaeology of the Human Sciences*, Tavistock, London, 1970, p.132
4. Bernard Fibicher, 'In the Name of ...', in *Simon Patterson*, Locus+, Newcastle-upon-Tyne, 2002, p.6. It should be pointed out that it was, in fact, the discussion of Foucault's reference to Borges by Fibicher that provided the catalyst. On reading his essay, Patterson and the designer Mark Thomson decided that using Borges's categories might be a good way in which to organise the visual material in the book.
5. André Breton
6. Patricia Bickers, 'Joking Apart', in the catalogue to Patterson's solo exhibition at Chisenhale Gallery, London, 22 June – 31 July 1994
7. Jean Baudrillard, *The Illusion of the End*, Polity, London, 1994, pp.62–3
8. See also, for example, Simon Patterson, *Name Painting 1987–1998*, Kohji Ogura Gallery, Nagoya, 1998. In the index, Béla Bartók becomes Béra Bartók.
9. Sir Joshua Reynolds, *Discourses on Art*, Collier – Macmillan, London, 1966, Discourse 13, pp.210-11
10. Erwin Panofsky, 'Et in Arcadia Ego: Poussin and the Elegiac Tradition', in *Meaning in the Visual Arts*, Penguin, Harmondsworth, 1970, p.340
11. ibid p.346
12. The status of the diptych in this exhibition is a fragile one. Patterson made the original work when still a student at Goldsmiths. It hung for some time in the college bar where, inevitably, it took several knocks. A second version, made for exhibition in 'Freeze', was bought by the designer Tony Arefin, though the work delivered to Arefin was, in fact, another remake as the 'Freeze' version was also damaged. Since it has not been possible to trace this among Arefin's estate, a fourth version has been made for this show. Once the show is over, it will be destroyed.
13. Kasimir Malevich, 'Introduction to the Theory of the Additional Element in Painting', reprinted in Chipp (ed), *Theories of Modern Art*, University of California, Berkeley, 1968, p.338

Landskip, 2000

The title *Landskip* derives from an 18th-century English rendering of 'Landscape'. The work is one of a set of unique photographs of a series of events staged at Compton Verney House, Warwickshire, involving the detonation of smoke grenades at strategic points in the tranquil setting of the park in which it is set. *Landskip* focuses on two aspects of Compton Verney: one being the fact that grounds were laid out by the famous 18th-century English landscape gardener, Lancelot 'Capability' Brown (1716-83), and the other being that during the Second World War, it was a secret location used by the Army for, amongst other things, smoke-screen tests. In much the same way that the Vorticists designed the 'Dazzle Ships' camouflage in the First World War for the Navy, art students from the Slade School of Art in London were drafted into the Army to help develop camouflage warfare techniques there in the Second World War.

With this history in mind, and inspired also by an episode from the Irish writer Laurence Sterne's great comic novel 'Tristram Shandy' of 1760 in which the protagonist is assisted by his uncle Toby in the reenactment in his garden of the Anglo-Dutch victory over the French at the siege of Namur in 1695. I wanted to create a daytime firework display in much the same way that artists were commissioned in the 17th and 18th centuries to design spectacles, including mock battles and firework displays, for their patrons.

Each grenade burned for 30 seconds or so allowing the smoke to hang for as long as weather conditions permitted. There were six colours: green, blue, red, purple, yellow and white. The display would last for about five minutes and took place three times a day over a period of one month. The effect was intended to be like a landscape painting with smudges of added colour. The ephemerality of smoke underscored the transience of the supposedly timeless and natural landscape. As the work was time-based, plumes of smoke occurred intermittently, recalling the theatrical device of the 'puff of smoke' (and the trap door) used to cause someone or something to appear or disappear at will. The colours are also linked to coded military markers used both to reveal and conceal. There are no prescribed meanings for the colours other than those that the military might choose to give them on any given day. The hoped-for effect is that of a history painting and a dreamlike evocation of a battlefield: art and the art of war.

The work was partly about drawing attention to the landscape, and to specific vistas, marking out the full extent of the original landscaped estate as laid out by 'Capability' Brown but which is now partly given over to agriculture. The desire was not to intervene permanently in what is already a work of art but to reintegrate, by means of the work, the part of 'Capability' Brown's work that survives with the rest of the new and ever-changing environment.

An unexpected outcome in some of the photographs, particularly those in which the sun's rays break through the cloud of coloured smoke, was the evocation of a clichéd image of divine intervention. All that was missing was the Voice of God, aka John Huston, from the film *The Ten Commandments*.
Simon Patterson, London, 19.04.04

Artist's statement for the exhibition '100 Artists See God' curated by John Baldessari and Meg Cranston at The Jewish Museum, San Francisco and ICA, London, 2004

above and following pages:
Landskip, 2000
Compton Verney,
Warwickshire
Curated by Locus+

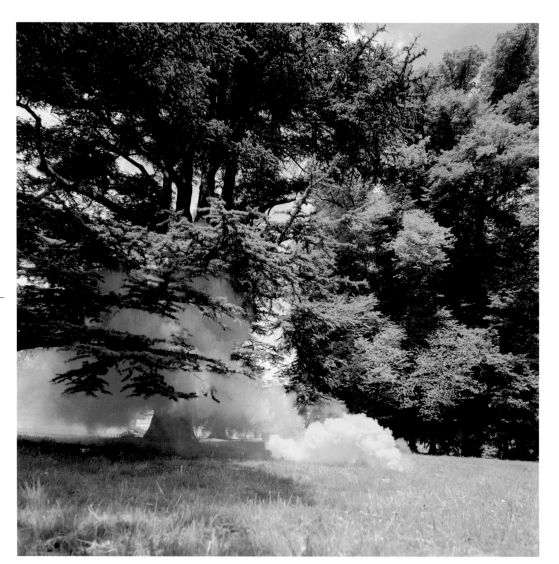

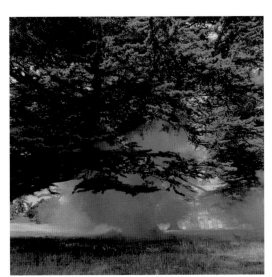
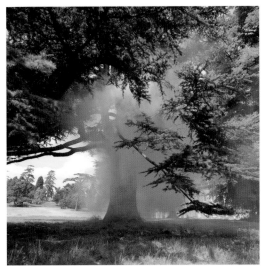

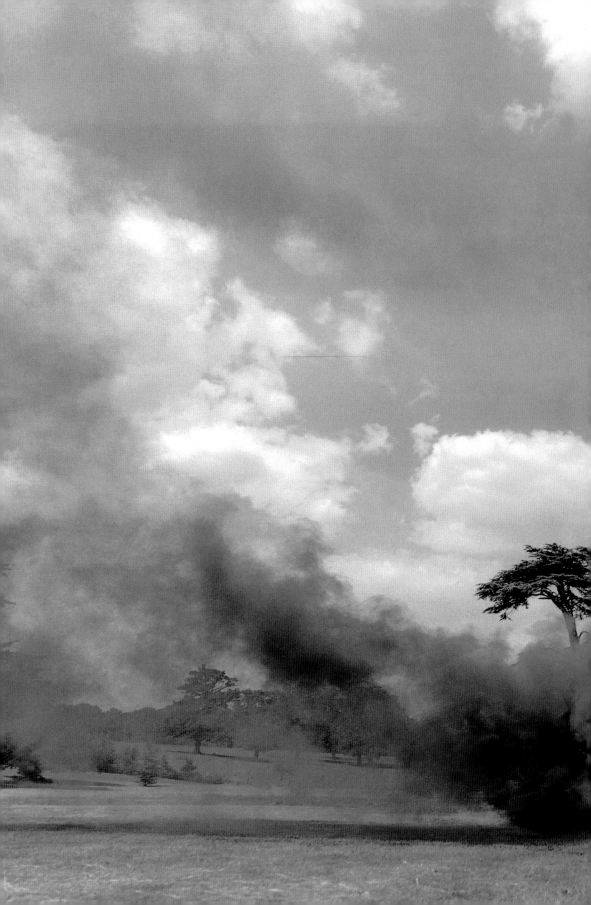

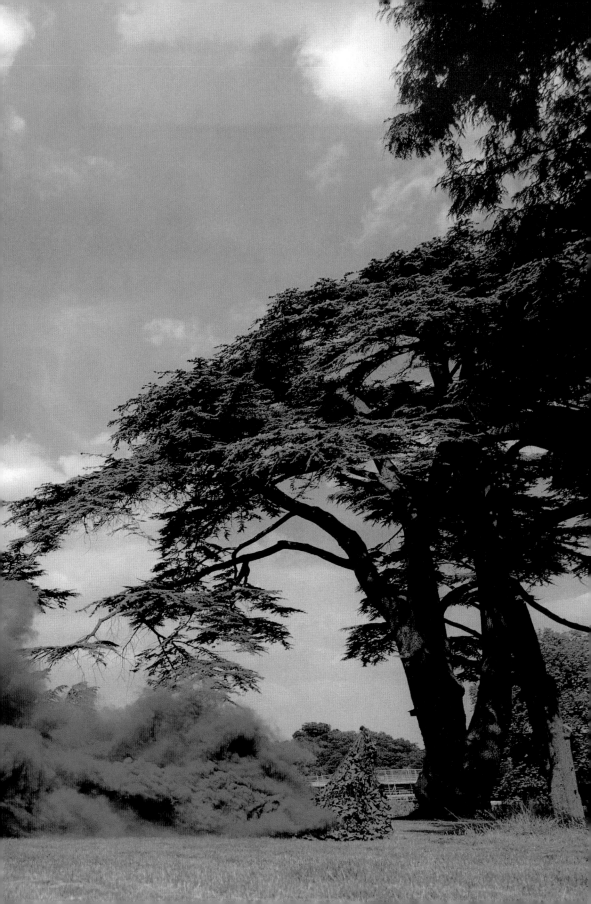

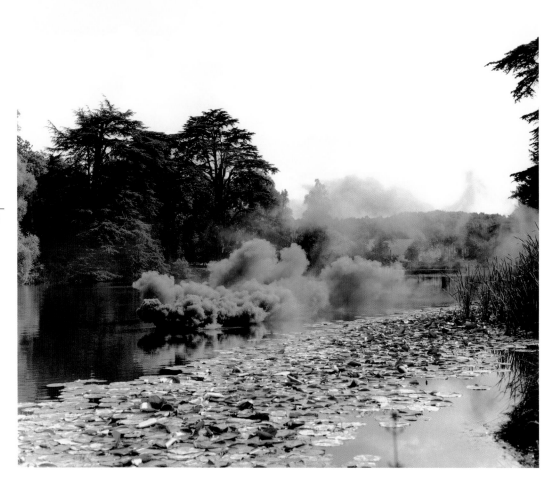

Escape Routine, 2002

DVD, 33 mins.
Director/Editor: Sharon Summers;
Narrator: Dilly Barlow (English);
Togo Igawa (Japanese)

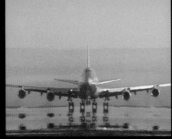

– Ladies and Gentlemen welcome aboard this Boeing 747-400.
– Please take a moment to familiarise yourself with our safety procedures....

– The safety leaflet in your seat area shows details of seat belts, oxygen masks, lifejackets and escape routes....

– Just at this juncture it is not out of place to describe the German transport chain, which is used by the German police almost exclusively for transporting prisoners.

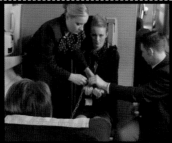

– The chain has two rings; one for each hand, one being located at the end of the chain, and the other in its centre. One lock is utilised for securing both hands....

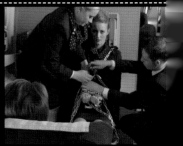

– The act may be varied to suit the particular occasion, but the following presentation covers many important points that will make it most effective.

– There is also a light which activates automatically and a whistle for attracting attention. DO NOT inflate your lifejacket until you are outside the aircraft....

– The word straitjacket alone conjures up to the mind pictures of violent maniacs and thoughts that tend to gruesome channels.

– In making the escape you go through fantastic gyrations, and eventually wriggle out of the fastenings. Imitators, as a rule, improvise their straitjacket that they can pull over their heads.

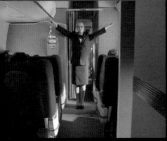

– Seen here is the Common English Regulation manacle for hands or feet....
– All of these cuffs have spring locks and are manipulated by screwing the key in to open, but they close with a snap

– Under water never substitute handcuffs except for fixed cuffs, otherwise they might go wrong with disastrous results.
– Strange, but almost all of the English cuffs are made in Birmingham or its vicinity

– May we remind you that smoking is not permitted anywhere on the aircraft including the toilets, which are fitted with smoke alarms....

- Portable telephones must be switched off for the duration of the flight.

- The seat belt is fastened like this, making sure it clicks firmly in place. The seat belt can be adjusted by simply pulling the strap like this and unfastened like this...

- When the 'Fasten Seat Belt' signs are illuminated you must return to your seat and fasten your belt securely.

- You may easily inject a tinge of humour into your work.
- But do not strain that point; it should come naturally and with ease or be left alone.

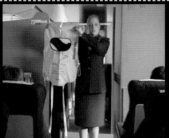

- Your lifejacket is stored underneath your seat.
- In the event of a landing on water, remove the lifejacket from its container and pull it over your head.

- Pass the tapes around your waist and tie them securely in a double bow at the side....
- The air may be topped up by using this mouthpiece.

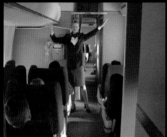

- If the cabin air supply fails, oxygen will be provided. Masks like this will appear automatically.

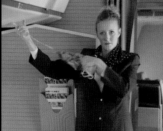

- Stay in your seat and pull a mask towards you. This will open your oxygen supply.

- Place the mask over your mouth and nose, like this, and breath normally....
- The band should be placed over your head.... Do make sure your own mask is fitted before helping anyone else.

- In winning your audience remember that 'manners make fortunes' so don't be

- Always have a short sentence ready in case a trick should go wrong.

- Aisle should be kept clear and hand baggage should be stored in the overhead

- Along with handcuffs and neck irons, there are special types of metal collars made to lock about a person's neck and from which escape is seemingly impossible.

- When you introduce an experiment apply yourself seriously. An old trick well done is far better than a new trick with no effect.
- You may think your trick is old but it is always new to your audience.

- Naturally you can allow anyone to bring along as many locks as they desire.

- Don't drag your tricks, but work as quickly as you can, bearing in mind the Latin proverb "make haste slowly".

- This is considered to be the greatest test possible in the United States of America.
- Never tell audiences how good you are: they will soon find that out for themselves.

- The emergency exits are on both sides of the aircraft. They are clearly marked.

[English-version, final sequence]

- "Art is long and life is short" says the Ancient Poet. The stage and its people in the light of history, make this a verity.

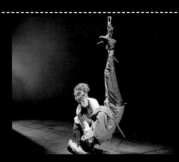

[Japanese-version, final sequence]

- "Art is long and life is short" says the Ancient Poet. The stage and its people in the light of history, make this a verity.

– Never work to fool a magician; always work to your audience. Walk right out onto the stage, and tell your tale to your audience, and perhaps many will believe it.

– The mail bag is the regulation type... sealed by means of a steel bar running through a row of metal eyelets.... The steel bar is secured by means of two locks.

– Don't think that because you perform a trick well, or the apparatus is detection-proof from the point of view of an ordinary audience, that you have conquered the world of mystery... that you reign supreme.

– Please take a moment now to locate the exit nearest to you, keeping in mind that the nearest usable exit may be behind you.

– In the unlikely event of having to use an escape slide, leave all (hand) baggage behind and remove high heeled shoes as they may tear the slide.

– To help you find your way to the exits, additional lighting will be provided in the aisles, at floor level.

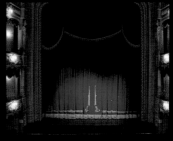

– Finally ladies and gentlemen, please take notice of the 'Fasten Seat Belt' sign and study the safety card. Thank you for your attention.

– Finally ladies and gentlemen, please take notice of the 'Fasten Seat Belt' sign and study the safety card. Thank you for your attention.

Color Match, 1997

Excerpt from audio CD, 12 mins., 40 secs.
Read by Tim Gudgin

- The FA Premier League
- Accrington Stanley, Pantone Red, Late Kick-Off
- Arsenal 2, Pantone Red 032 U
- Aston Villa 1, Pantone Rubine Red U
- Barnsley St Peter's, Pantone Warm Red, Late Kick-Off
- Barrow, Pantone Red, Late Kick-Off
- Blackburn Rovers 0, Pantone Warm Red U
- Bolton Wanderers 0, Pantone Rhodamine Red U
- Bootle 0, Pantone Red 1807 U
- Bournemouth & Boscombe Athletic 3, Pantone Red 1817 U
- Chelsea 2, Pantone Red 1797 U
- Coventry City 0, Pantone Red 200 U
- Darwen, Pantone Red, Late Kick-Off
- Durham City, Pantone Red, Late Kick-Off
- Everton 1, Pantone Process Magenta U
- Leeds United 4, Pantone Fluorescent Red 805 U, 2x
- Liverpool 2, Pantone Red, 1788U 2x
- Manchester City, 0, Pantone Red 165 U, 2x
- Manchester United 3, Pantone Warm Red U, 2x
- Middlesbrough 1, Pantone Red 174 U
- Nelson, Pantone Red, Late Kick-Off
- Newcastle United 2, Pantone Red 173 U
- Nottingham Forest 3, Pantone Red 1742 U
- Queen's Park Rangers 3, Pantone Orange Red 172 U
- Sheffield Wednesday 1, Pantone Orange Red 1655 U
- Southampton 0, Pantone Orange Red 1635 U
- Tottenham Hotspur 1, Pantone Orange 021, U
- Walsall Town Swifts, Pantone Orange, Late Kick-Off
- West Ham United 0, Pantone Fluorescent Orange 804 U
- Wimbledon 2, Pantone Orange 143 U
- Woolwich Arsenal, Pantone Orange, Late Kick-Off

- First Division
- Aldershot 1, Pantone Yellow 112 U
- Ardwick, Pantone Yellow, Late Kick-Off
- Barnsley 1, Pantone Yellow U, 2x
- Birmingham City 2, Pantone Yellow U
- Bradford Park Avenue, Pantone Yellow, Late Kick-Off
- Charlton Athletic 0, Pantone Yellow 101 U
- Crystal Palace 0, Pantone Yellow 100 U
- Derby County 2, Pantone Yellow 012 U
- Grimsby Town 0, Pantone Process Yellow U
- Huddersfield Town 1, Pantone Fluorescent Yellow 803 U, 2x
- Ipswich Town 1, Pantone Yellow 106 U
- Leeds City, Pantone Yellow, Late Kick-Off
- Leicester City 0, Pantone Yellow 107 U
- Leicester Fosse, Pantone Yellow, Late Kick-Off
- Loughborough Town, Pantone Yellow, Late Kick-Off
- Luton Town 0, Pantone Yellow 108 U
- Maidstone United, Pantone Yellow, Late Kick-Off
- Merthyr Town, Pantone Yellow, Late Kick-Off
- Middlesbrough Ironopolis, Pantone Yellow, Late Kick-Off
- Millwall 1, Pantone Yellow 109 U
- New Brighton, Pantone Yellow Green, Late Kick-Off
- New Brighton Tower, Pantone Yellow Green, Late Kick-Off
- Norwich City 0, Pantone Yellow Green 396 U
- Oldham Athletic 2, Pantone Yellow Green 388 U
- Portsmouth 0, Pantone Yellow Green 381 U
- Port Vale 0, Pantone Fluorescent Green 802 U, 2x
- Reading 1, Pantone Green 360 U
- Rotherham Town, Pantone Green, Late Kick-Off
- Scunthorpe & Lindsey United, Pantone Green, Late Kick-Off
- Sheffield United 1, Pantone Green 359 U
- Southend United 1, Pantone Green 352 U
- Stoke City 2, Pantone Green 351 U
- Sunderland 4, Pantone Green 353 U
- Swansea Town, Pantone Green, Late Kick-Off
- Thames Association, Pantone Green, Late Kick-Off
- Tranmere Rovers 1, Pantone Green 340 U
- Watford 0, Pantone Green U
- West Bromwich Albion 2, Pantone Green 3268 U
 [...].

Le Match des couleurs, 2000

DVD projection, 9 mins.
Read by Eugéne Saccomano

- Voici, Le Première Division
- Auxerre 1, Équivalent Hexadecimal, Magenta CE007B
- Bastia 0, Équivalent Hexadecimal, Magenta D63194
- Bordeaux 1, Équivalent Hexadecimal, Magenta DE5AAD
- Brest, Équivalent Hexadecimal, Mauve, Annule
- Club Français, Équivalent Hexadecimal, Mauve, Annule
- Exceislor, Équivalent Hexadecimal, Mauve, Annule,
- Le Havre 3, Équivalent Hexadecimal, Pourpre 9C2994
- Lens 2, Équivalent Hexadecimal, Pourpre 8C007B
- Limoges, Équivalent Hexadecimal, Pourpre, Annule,
- Lyon 1, Équivalent Hexadecimal, Pourpre 5A0052
- Marseille 1, Équivalent Hexadecimal, Pourpre 4A0042
- Metz 0, Équivalent Hexadecimal, Pourpre 390031
- Monaco 4, Équivalent Hexadecimal, Pourpre 180042
- Montpellier 0, Équivalent Hexadecimal, Pourpre 21004A
- Mulhouse, Équivalent Hexadecimal, Pourpre, Annule
- Nancy 2, Équivalent Hexadecimal, Pourpre 31007B
- Nantes 3, Équivalent Hexadecimal, Pourpre 522994
- O Lillois, Équivalent Hexadecimal, Violet, Annule
- Paris-Saint-Germain 0, Équivalent Hexadecimal, Violet C6B5DE
- Rennes 1, Équivalent Hexadecimal, Violet BDC6DE
- Saint-Étienne 2, Équivalent Hexadecimal, Bleu, 949CCE
- Sedan 1, Équivalent Hexadecimal, Bleu 6373B5
- Sète, Équivalent Hexadecimal, Bleu, Annule
- S-O Montpellier, Équivalent Hexadecimal, Bleu, Annule
- Stade Français, Équivalent Hexadecimal, Bleu, Annule
- Strasbourg 1, Équivalent Hexadecimal, Bleu 00184A
- Toulon, Équivalent Hexadecimal, Bleu-Vert, Annule
- Troyes 2, Équivalent Hexadecimal, Turquoise, 006B84

- Seconde Division
- Aix-en-Provence, Équivalent Hexadecimal, Turquoise, Annule
- Ajaccio 0, Équivalent Hexadecimal, Cyan 31B5D6
- Amiens 1, Équivalent Hexadecimal, Cyan 63C6DE
- Avignon, Équivalent Hexadecimal, Cyan, Annule
- Béziers, Équivalent Hexadecimal, Cyan-Vert, Annule
- Caen 3, Équivalent Hexadecimal, Cyan-Vert 31ADA5
- Cannes 1, Équivalent Hexadecimal, Vert 089494
- Ca Paris, Équivalent Hexadecimal, Vert, Annule
- Châteauroux 0, Équivalent Hexadecimal, Vert 006363
- Créteil 0, Équivalent Hexadecimal, Vert, 004A4A
- Fc Nancy, Équivalent Hexadecimal, Vert, Annule
- Gueugnon 1, Équivalent Hexadecimal, Vert, 103910
- Guingamp 1, Équivalent Hexadecimal, Vert, 184A18
- Hyéres, Équivalent Hexadecimal, Vert, Annule
- Laval 1, Équivalent Hexadecimal, Vert 229C39
- Le Mans 2, Équivalent Hexadecimal, Vert 52B552
- Lille 3, Équivalent Hexadecimal, Vert A5DE94
- Lorient 0, Équivalent Hexadecimal, Vert CEEFBD

- Louhans-Cuiseaux 1, Équivalent Hexadecimal, Vert DEF3BD
- Nice 0, Équivalent Hexadecimal, Vert C6EF8C
- Nîmes 0, Équivalent Hexadecimal, Vert ADDE63
- Niort 2, Équivalent Hexadecimal, Vert 7BCC618
- Rouen, Équivalent Hexadecimal, Vert, Annule
- Sochaux 2, Équivalent Hexadecimal, Vert 527B10
- Toulouse, Équivalent Hexadecimal, Vert, Annule
- Valence 1, Équivalent Hexadecimal, Vert 6B6B21
- Wasquehal 1, Équivalent Hexadecimal, Vert, 8C9429

- National
- Alès, Équivalent Hexadecimal, Vert, Annule
- Angers 1, Équivalent Hexadecimal, Vert-Jaune, DEF763
- Angoulême, Équivalent Hexadecimal, Vert-Jaune, Annule
- Antibes, Équivalent Hexadecimal, Vert-Jaune, Annule
- Beauvais 1, Équivalent Hexadecimal, Jaune FFFFC6
- Besancon 0, Équivalent Hexadecimal, Jaune FFFF6B
- Clermont 2, Équivalent Hexadecimal, Jaune FFFF42
- Colmar, Équivalent Hexadecimal, Jaune, Annule
- C.O.R.T, Équivalent Hexadecimal, Jaune-Vert, Annule
- Évry 3, Équivalent Hexadecimal, Jaune-Vert AD9410
- Fives, Équivalent Hexadecimal, Vert, Annule
- Fréjus 2, Équivalent Hexadecimal, Vert 635208
- Gazelec Ajaccio 2, Équivalent Hexadecimal, Vert-Brun 632910
- Grenoble 0, Équivalent Hexadecimal, Brun 844D18
- Istres 1, Équivalent Hexadecimal, Brun D66321
- Martigues 1, Équivalent Hexadecimal, Orange FF8429
- Noisy-le-Sec 1, Équivalent Hexadecimal, Orange FF9C4A
- Pacy 6, Équivalent Hexadecimal, Orange FFCE9C
- Paris Football-Club 0, Équivalent Hexadecimal, Orange FFE7C6
- Pau 1, Équivalent Hexadecimal, Orange-Rouge, FFC645
- Racing Club de France 2, Équivalent Hexadecimal, Rouge, FF6342
- Raon-L'étape 1, Équivalent Hexadecimal, Rouge FF0000
- Red Star 0, Équivalent Hexadecimal, Rouge D60000
- Reims 1, Équivalent Hexadecimal, Rouge 840000
- RC Roubaix, Équivalent Hexadecimal, Marron, Annule
- Thouars 4, Équivalent Hexadecimal, Marron-Magenta 6B0042
- Tours, Équivalent Hexadecimal, Magenta, Annule
- Valenciennes 1, Équivalent Hexadecimal, Magenta CE007B

- VOILÀ

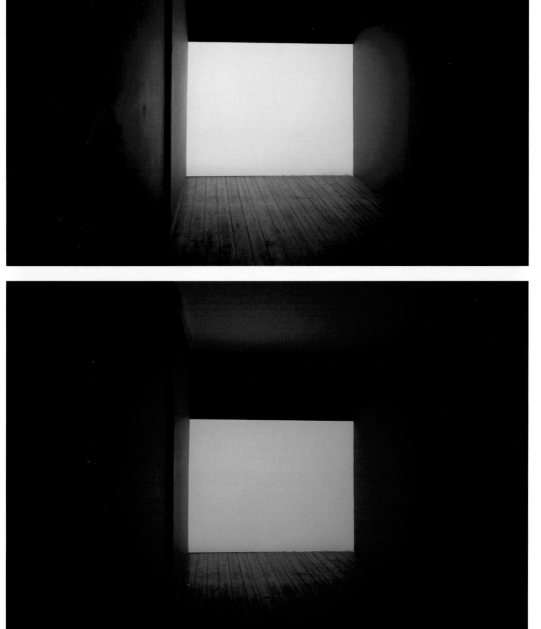

Match,

Cavanagh

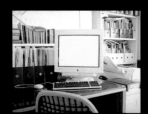

- The Scottish Premier League
- Abercorn, Pantone Yellow, Late Result
- Albion Rovers, Pantone Yellow, Late Result
- Armdale, Pantone Yellow, Late Result
- Bathgate, Pantone Yellow, Late Result
- Bo' Ness, Pantone Yellow, Late Result
- Cambuslang, Pantone Yellow, Late Result

Heart of Midlothian 1, Pantone Orange 021 C
Hibernian 2, Pantone Warm Red 1585 C
Inverness Clachnacudden, Pantone Warm Red, Late Result
Johnstone, Pantone Warm Red, Late Result
Kilmarnock 1, Pantone Warm Red, 1665 C
Lochgelly United, Pantone Warm Red, Late Result
Motherwell 0, Pantone Warm Red C

- Northern, Pantone Red, Late Result
- Queen's Park, Pantone Red, Late Result
- Rangers 0, Pantone Red 192 C
- Ross County, Pantone Red, Late Result
- St Bernard, Pantone Red, Late Result
- St Johnstone 0, Pantone Red 206 C
- Third Lanark, Pantone Red, Late Result

Eastern, Pantone Purple, Late Result
Falkirk 1, Pantone Purple 258 C
Ferranti Thistle, Pantone Purple, Late Result
Galston, Pantone Purple, Late Result
Greenock Morton 2, Pantone Purple 2582 C
Hamilton Academicals 3, Pantone Purple 2592 C
Hurlford, Pantone Purple, Late Result

- King's Park, Pantone Purple, Late Result
- Mid Annandale, Pantone Purple, Late Result
- Montrose, Pantone Purple, Late Result
- Partick Thistle 3, Pantone Purple 2587 C
- Peebles Rovers, Pantone Violet, Late Result
- Raith Rovers 1, Pantone Violet 265 C
- Renton, Pantone Violet, Late Result

Clydebank 3, Pantone Blue, 3015 C
Cowdenbeath, Pantone Process Blue, Late Result
Dumbarton, Pantone Turquoise, Late Result
Dundee Harp, Pantone Turquoise, Late Result
Dundee Wanderers, Pantone Turquoise, Late Result
East Fife 5, Pantone Green , 3282 C
East Kilbride Thistle, Pantone Green, Late Result

- East Stirlingshire, Pantone Green, Late Result
- Edinburgh City, Pantone Green, Late Result
- Forfar Athletic 4, Pantone Green, C
- Helensburgh, Pantone Green, Late Result
- Inverness-Caledonian Thistle 2, Pantone Green, 3415 C
- Linthouse, Pantone Green, Late Result
- Livingston 2, Pantone Green, 354 C

- Celtic 1, Pantone Yellow 122 C
- Clackmannan, Pantone Yellow, Late Result
- Cowlairs, Pantone Yellow, Late Result
- Dumbreck, Pantone Yellow, Late Result

- Dundee United, Pantone Yellow/Orange, Late Result
- Dunfermline Athletic 2, Pantone Orange 1375 C
- Dykehead, Pantone Orange, Late Result
- E.S. Clydebank, Pantone Orange, Late Result
- Granville, Pantone Orange, Late Result

- Scottish First Division
- Aberdeen, Pantone Magenta, Late Result
- Airdrieonians 2, Pantone Rubine Red 220 C
- Alloa Athletic, Pantone Rhodamine Red, Late Result
- Ayr, Pantone Rhodamine Red, Late Result

- Ayr Parkhouse, Pantone Purple, Late Result
- Ayr Utd 0, Pantone Purple 240 C
- Beith, Pantone Purple, Late Result
- Broxburn Shamrock, Pantone Purple, Late Result
- Clydesdale, Pantone Purple, Late Result
- Dumbarton Harp, Pantone Purple, Late Result
- Dundee 3, Pantone Purple C

- Royal Albert, Pantone Violet, Late Result
- St Mirren 0, Pantone Violet C
- Stevenson United, Pantone Blue, Late Result
- Stirling Albion 1, Pantone Blue 072 C
- Vale of Leven, Pantone Blue, Late Result

- Scottish Second Division
- Arbroath, Pantone Reflex Blue, Late Result
- Arthurlie, Pantone Blue, Late Result
- Berwick Rangers, Pantone Blue, Late Result
- Brechin City 2, Pantone Blue, 2935 C
- Broxburn United, Pantone Blue, Late Result
- Clyde 0, Pantone Blue, 3005 C

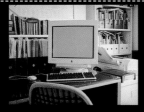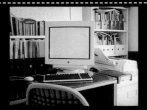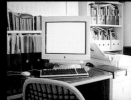

- Meadowbank Thistle, Pantone Green, Late Result
- Morton, Pantone Green, Late Result
- Nithsdale Wanderers, Pantone Green, Late Result
- Port Glasgow Athletic, Pantone Green, Late Result
- Queen Of The South 3, Pantone Green, 375 C
- Queen Of The South Wanderers, Pantone Green/Yellow, Late Result

- Solway Star, Pantone Green/Yellow, Late Result
- Stenhousemuir 1, Pantone Green/Yellow, 396 C
- Stranraer, 0, Pantone Yellow, 3965 C

Time Piece, 2005

35mm film, 1 min.

Dear Fiona,
We shot the 35mm footage of the watches this weekend. Re: the sound, I decided that it would be best to use fit(!) actors rather than athletes because non-professionals might be intimidated by the mic.

In the test shoot it became clear that the watches swinging forward didn't work and was more akin to *The Pit and the Pendulum* than the hopefully more erotic result that I was aiming at. I have decided to drop the whole surround sound idea, too, as unnecessary. For this reason the work will return to the simpler original idea of stereo and the swinging watches going in and out of phase, visually and aurally.

Left and Right; Male and Female; Gold and Silver; Sun and Moon etc.

Re: sources (sound): Kraftwerk's single *Tour de France* and its homoerotic undertones with its use of overlaid edits of cyclists breathing and Fred Zinnemann's *High Noon*, both the cross-cut visuals and Tiomkin's score (on viewing the movie again, I was surprised to find that clocks hardly figure, instead it is suggested by the score). What interested me was the timings of the shots of the climactic scenes which is what I have chosen to base the edits on.
Simon Patterson, 25.01.05
Email to Fiona Bradley, The Fruitmarket Gallery, Edinburgh

left, opposite and overleaf:
Time Piece, 2005
Production stills

SELECTED BIOGRAPHY

1967 Born in England
1986–89 Goldsmiths' College, London,
BA Fine Art

Solo Exhibitions

1989 – *Simon Patterson*, Third Eye Centre,
Glasgow
1991 – *Allahu Akbar*, Riverside Studios,
London
1993 – *Monkey Business*, The Grey Art
Gallery, New York
1994 – *General Assembly*, Chisenhale
Gallery, London. Toured to Angel
Row Gallery, Nottingham
– *Simon Patterson*, Kluuvin Gallery,
Helsinki
1995 – *Simon Patterson*, Gandy Gallery,
Prague
– *Sister Ships*, The Customs House,
South Shields
– *Midway*, Artium, Fukuoka
– *Simon Patterson*, Röntgen
Kunstinstitut, Tokyo
– *Simon Patterson*, Kohji Ogura
Gallery, Nagoya
1996 – *Simon Patterson*, Lisson Gallery,
London
– *Simon Patterson*, MCA, Chicago
1997 – *Simon Patterson*, Röntgen
Kunstraum, Tokyo
– *Wall Drawings*, Kunsthaus Zürich
– *Spies*, Gandy Gallery, Prague
1998 – *Name Paintings*, Kohji Ogura
Gallery, Nagoya
– *Simon Patterson*, Yamaguchi
Gallery, Osaka
– *New Work*, Röntgen
Kunstraum,Tokyo
– *Simon Patterson*, Mitaka City Art
Center, Tokyo
1999 – *Simon Patterson*, Magazin 4,
Bregenz
2000 – *Manned Flight, 1999-*, Fig-1,
London
– *Simon Patterson*, VTO Gallery,
London
– *Le Match des couleurs*,
artconnexion, Lille
– *Simon Patterson*, Sies + Höke
Galerie, Düsseldorf
2003 – *Midway*, Roentgenwerke, Tokyo
– *Domini Canes – Hounds of God*,
Lowood Gallery and Kennels,
Armathwaite, Cumbria
– *PaintstenroomS*, gSM, London
2005 – *Simon Patterson, High Noon*, The
Fruitmarket Gallery, Edinburgh
– *Simon Patterson, High Noon*, Ikon
Gallery, Birmingham
– *Simon Patterson*, Lisson Gallery,
London

Group Exhibitions

1988 – *Freeze*, (Parts 1 & 3), PLA Building,
London
1989 – *1789–1989: Ideas and Images of
Revolution*, Kettles Yard Gallery,
Cambridge
1990 – *Simon Patterson and Christopher
Muller*, Milch Gallery, Guilford St.
London
– *Group Show Part 4*, Milch Gallery,
Guilford St. London
1991 – *Angus Hood, Simon Patterson and
Thomas Walsh*,
Transmission Gallery, Glasgow
1992 – *Doubletake: Collective Memory and
Current Art*, Hayward Gallery,
London. Toured to Kunsthalle,
Wien, 1993
– *A Modest Proposal*, Milch Gallery,
Great Russell St. London
– *Etats Spécifiques*, Musée des
Beaux-Arts André Malraux, Le
Havre
– *With Attitude*, Galerie Rodolphe
Janssen, Brussels
– *In and Out and Back and Forth*, 578
Broadway, New York
1993 – *Aperto*, XLV Biennale di Venezia,
Venice
– *Wonderful Life*, Lisson Gallery,
London
– *Alan Smithee*, Galerie Philomene
Magers, Cologne
1994 – *Surface de Réparations*, FRAC
Bourgogne, Dijon
– *Fiction-Non Fiction*, Galleria
Alessandra Bonomo, Rome
– *Esprit d'Amusement*, Grazer
Kunstverein im Stadtmuseum,
Graz
– *Mapping*, MoMA, New York
1995 – *The Institute of Cultural Anxiety –
Works from the Collection*, ICA,
London
– *Európa: Kreáció & Re-Kreáció*,
Mucsarnok/Kunsthalle, Budapest
– *Ideal Standard Summertime*, Lisson
Gallery, London
– *Nowa sztuka w Wielkiej Brytanii*,
Museum Sztuki, Lódz
1996 – *Homo Ecologicus: Per una cultura
de la Sostenibilitat*, Fundació Juan
Miró, Barcelona
– *Obcutek za red*, MoMA, Ljubljana
– *Words*, Kohji Ogura Gallery, MoCA,
Nagoya
– *Goal*, Context Gallery, Derry
– *The Turner Prize*, Tate Gallery,
London
1997 – *Magie der Zahl: in der Kunst des
20. Jahrhunderts*, Staatsgalerie,
Stuttgart
– *Material Culture: the Object in
British Art in the 1980s and 90s*,
Hayward Gallery, London
– *Cartographers*, Galerjie Grada
Zagreba, Zagreb. Toured to Centre
for Contemporary Art, Zamek;
Ujazdowski, Warsaw; the
Mücsarnok, Budapest;
Umetnostna Galerija, Maribor

and Wleeshal, Middleburg
– *Dimensions Variable*, Helsingfors
Stadsmuseum, Helsinki; IASPIS,
Stockholm; Soros Foundation,
Kiev; Gallery Zacheta, Warsaw;
Kunstasammlungen, Chemnitz;
Prague Castle, Prague
– *Follow Me*, Kunstverein, Hannover
– *Sensation, Young British Artists
from the Saatchi Collection*, Royal
Academy, London. Toured to
Hamburger Bahnof, Berlin, 1998
and Brooklyn Museum, New York,
1999
– *Anthology*, Eagle Gallery, London;
Talbot Rice Gallery, Edinburgh,
1999
1998 – *Inbreeder: Some English
Aristocracies*, Collective Gallery,
Edinburgh
– *Tracings*, Ormeau Bath Gallery,
Belfast
– *A to Z*, The Approach Gallery,
London
– *Urban*, Tate Gallery, Liverpool
– *Modern British Art*, Tate Gallery,
Liverpool
– *Deep Thought*, Basilico Fine Arts,
New York
– *Kunst in der Stadt 2*, Bregenzer
Kunstverein, Bregenz
– *Distinctive Elements*, National
Museum of Contemporary Art,
Seoul
– *Made in London*, Museu de
Electridade, Lisbon
1999 – *L.A. International*, Chacmool
Gallery, Los Angeles
– *Projects 70*, MoMA, New York
2000 – *Lisson Gallery in Covent Garden*,
Kean Street, London
– *La Beauté du geste (l'art, le sport,
et cætera)*, Centre d'art
Contemporain de Vassivière en
Limousin
2001 – *Teeth and Trousers*, Cell Projects,
London
– *London Underground*, Sungkok Art
Museum, Seoul. Toured to
Museum of Fine Art, Taipei
2002 – *Con Trick: Art and Magic*, Site
Gallery, Sheffield. Toured to Glynn
Vivian Art Gallery, Swansea
– *The Rowan Collection:
Contemporary British and Irish Art*,
IMMA, Dublin
– *The World May be Fantastic*,
Biennale of Sydney, 2002
2003 – *Mono*, Roentgenwerke, Tokyo
– *Typeofgravy*, Cell Projects, London
– *East of Eden; Forbidden Fruit in
London*, Wharf Road, London
– *The Distance Between Me and You*,
Lisson Gallery, London
– *A Bigger Splash: Arte Britânica da
Tate, 1960–2003*. Pavilhão Lucas
Norgueira Garcez and Instituto
Tomie Ohtake, Sao Paulo
2004 – *100 Artists See God*, Independent
Curators International, The Jewish
Museum, San Francisco. Toured
to ICA, London, 2005

SELECTED BIBLIOGRAPHY

Artist's Books

- *Republicans*, artist's book, publ. Arefin Inc., Simon Patterson and The Third Eye Centre, Glasgow, ed. of 700: pb., 25 hb.
- *Rex Reason*, artist's book; ed. of 1; hand-bound letterpress presentation copy, publ. Bookworks, commissioned by The Arts Council of Great Britain for The Prudential and Arts Council of Great Britain Award, 1993. Artist's book; ed. of 10 copies, hand-bound letterpress, publ. Bookworks, London, 1994. Artist's book; pb ed. of 2000, offset lithography, publ. Bookworks, London, 1994
- *PaintstenroomS*, ed. of 20, publ. by IDUK and Locus+, London and Newcastle-upon-Tyne, 2004

Catalogues

- *Freeze*, London Docklands, London, 1988
- *After 1789: Ideas and Images of Revolution*, Kettle's Yard Gallery, 1989
- *Doubletake: Collective Memory and Current Art*, the South Bank Centre and Parkett Publishers, 1992
- *Etats Spécifiques*, Musée des Beaux-Arts André Malraux, Le Havre, 1992
- *In and Out and Back and Forth*, Idaho Editions, London, 1992
- *Doubletake: Kolektives Gedächtnis & Heutige Kunst*, Kunsthalle Wien and the South Bank Centre, 1993
- *XLV Esposizione Internazionale d'Arte: Punti Cardinali dell'Arte; La Biennale di Venezia*, Marsilio Editori S.P.A., Venezia, 1993, vols. I and II
- *XLV Biennale di Venezia: Flash Art Aperto '93; Emergency/Emergenza*, Giancarlo Politi, Milan, 1993
- *Galerie Gruppe Grün*, Galerie Gruppe Grün, Bremen, 1993
- *Alan Smithee*, Galerie Philomene Magers, Köln, 1993
- *High Fidelity*, Kohji Ogura Gallery, Nagoya, 1993
- *Wall to Wall*, The South Bank Centre, London, 1994
- *Simon Patterson – General Assembly*, Chisenhale Gallery, London, 1994
- *Mapping*, MoMA, New York, 1994, publ. Harry N. Abrams Inc.
- *The nvisible Museum* [sic], publ. Peter Fleissig, London, 1994
- *The Institute of Cultural Anxiety: Works from the Collection*, ICA, London, 1994
- *Európa: Kreáció & Re-Kreáció/Europe: Creation and Re-Creation*, Kunsthalle/Mücsarnok, Budapest, 1994
- *Surface de Réparations*, FRAC de Bourgogne, Dijon, 1995
- *Nowa sztuka w Wielkiej Brytanii/New Art in Britain*, Muzeum Sztuki, Lódz, 1995
- *Homo Ecologicus: Per una Cultura de la Sostenibilitat*, Fundació Joan Miró, Barcelona and the Departament de Cultura de la Generalitat de Catalunya, 1996

- *Art et Mégalopole: RN 86*, L'Institut pour l'Art et la Ville, Maison du Rhône, Givors and Pierre Mardaga Editeur, Liège, 1996
- *Obcutek za red/The Sense of Order*, Moderna Galerija Ljubljana/Museum of Modern Art, Slovenia, 1996
- *Magie der Zahl: In der Kunst des 20. Jahrhunderts*, Staatsgalerie Stuttgart
- *Material Culture: the Object in British Art in the 1980s & '90s*, The South Bank Centre, London, 1997
- *Wall Drawings*, Kunsthaus Zürich, 1997
- *Sensation: Young British Artists from the Saatchi Collection*, Royal Academy of Arts, 1997
- *Follow Me*, publ. Landschaftsverband der ehemaliigen Herzoogtümer Bremen und Verden, 1997
- *Dimensions Variable*, publ. The British Council, 1997
- *Distinctive Elements*, National Museum of Contemporary Art, Seoul, publ. The British Council and The Museum of Contemporary Art, Seoul, 1998
- *Simon Patterson: Playrooms of Words and Images*, publ. Mitaka Art Centre, Tokyo, 1998
- *Kunst in der Stadt 2*, publ. Bregenzer Kunstverein, Bregenz, 1998
- *Simon Patterson: Name Painting*, publ. Kohji Ogura Gallery, Nagoya, 1998
- *Representing Britain: 100 Works from the Tate Collections 1500–2000*, publ. Tate Publishing, 2000
- *British Council Collection at UBS Warburgs*, 2001
- *Fig-1*, publ. Tate Publishing, 2001
- *The Rowan Collection: Contemporary British and Irish Art*, publ. IMMA, Dublin, 2002
- *Con Art*, publ. Site Gallery, Sheffield, 2002
- *Biennale of Sydney: (The World) May Be Fantastic*, 2002
- *Magazin im Magizin 2*, publ. Magazin 4 Voralberger Kunstverein, Bregenz, 2002
- *Simon Patterson*, publ. Locus+, 2002
- *From Arkhipov to Zittel; Selected Ikon Off-site Projects 2000–2001*, publ. Ikon Gallery, Birmingham, 2002
- *A Bigger Splash: Arte Britânica da Tate/British Art from the Tate, 1960–2003*, publ. Brasil Connects, Sao Paulo, 2003
- *East of Eden; Forbidden Fruit in London*, 2004
- *100 Artists See God*, publ. Independent Curators International, 2004
- *Simon Patterson High Noon*, publ. The Fruitmarket Gallery, Edinburgh and Ikon Gallery, Birmingham, 2005

Interviews

- Collings, Matthew: *The Late Show*, BBC 2, 'Goldsmiths', Apr. 1989
- Gillick, Liam: *Audio Arts Magazine*, 'Venice Biennale 1993', Sept. 1993
- Makabe, Kaori: *Bijutsu Techo Monthly Art Magazine*, May 1994
- Greenberg, Sarah: *Tate: The Art Magazine*, 'The Word According to Simon Patterson', Winter 1994
- Kastner, Jeffrey: *Art News*, 'Great Britain '94 British Art Today: A New Powerhouse', Sept. 1994
- Gooding, Mel: *Audio Arts Magazine*, 'Simon Patterson', 1996
- Pirman, Alenka: *M' ARS: Magazine of the MoMA Ljubljana*, 'Imena so le besede za stvari', 1996
- Greenberg, Sarah: *Tate: The Art Magazine*, 'Christ as a Sweeper', Summer 1996
- Pirman, Alenka: *Sculpture*, 'Names are Words for Things', Jan. 1997
- Glass, Ian: *Channel Four News*, 19 Jun. 1996
- Haughey, Nuala: *The Irish Times*, 'Turner Prize nominee Simon Patterson talks to Nuala Haughey about new interpretations of everyday images: Football team formations by divine inspiration', 20 Aug. 1996
- Wills, Peter: *British Satellite News*, Nov. 1996
- Paxman, Nikki: *Night Waves*, BBC Radio 3, 26 Nov. 1996
- Trüby, Larissa and Köster, Juri: *HFF München for NRT*, 'Brit Art', 1996/7, 30 mins.; 'Unlabled' for *The Kasel Documentary Festival*, 1997, 45 mins.
- Fibicher, Bernhard: *Wall Drawings*, Kunsthaus Zürich, 1997
- *The South Bank Show* LWT and Channel Four, 'Socerrarti', 31 May 1998
- Francis, Mark: 'Simon Patterson: Manned Flight', *Fig-1*, 2001
- Dawson, Mike and Griffiths, Jane: 'Ideal Worlds: an Interview with Simon Patterson', *Flux*, Dec. 2000/Jan 2001
- Goldstein, Lauren: *Time, Special Issue: Fast Forward Europe*, 'First Person: An Interview with Simon Patterson', Winter 2000
- *The Art Magazine Wolgan Misool*, 'Simon Patterson', Feb. 2001
- Marlow, Tim: *Artworks*, LWT, 23 Jun. 2002 BBC Radio 12 July, 2002
- Kröner, Magdalena: 'Wenn ich es mir leisten Könnte, würde ich jemanden furs malen bezahlen', *Kunstforum International* 2000
- Rob Flint: 'Baggage Reclaim', *Resonance FM*, 31 Mar. 2003
- Penketh, Claire: '100 Artists See God', *BBC World Service*, 14 Nov. 2004

List of works

Simon Patterson
High Noon

The Fruitmarket Gallery
26 February – 1 May 2005

Ikon Gallery
8 June – 17 July 2005

THE FRUITMARKET GALLERY

General Assembly, 1994
Steel, wood, paint and text
Dimensions variable
Courtesy Lisson Gallery, London

Gunmen (Bat Masterton), 1996
Gunmen (Billy the Kid), 1996
Gunmen (Jesse James), 1996
Courtesy Lisson Gallery, London
Gunmen (Wild Bill Hickock), 1996
Courtesy the British Council
Marine plywood, formica
and perspex
Minimum length 244cm

Harry Houdini, 1989
Silkscreen on acrylic
gesso on canvas
152.4 x 121.9cm
Collection of Patricia Bickers, London

The Last Supper Arranged According to the Sweeper Formation (Jesus Christ in Goal), 1990
Wall drawing
Dimensions variable
Private collection, London

Ur, 2005
Wall drawing
Dimensions variable
Courtesy the artist and
Lisson Gallery, London
Commissioned by
The Fruitmarket Gallery, Edinburgh

THE FRUITMARKET GALLERY AND IKON GALLERY

Colour Match, 2001
Screensaver, 9 mins.
Unlimited edition
Published by Tate Enterprises
Courtesy the artist

The Great Bear, 1992
4-colour lithograph in glass
and aluminium frame
Edition of 50
109.2 x 134.6cm
Courtesy the artist

Escape Routine, 2002
DVD, 33 mins.
Directed by Sharon Summers
Commissioned and produced
by Locus +, Newcastle-upon-
Tyne, in association with
Jay Films & Video

Richard Burton/Elizabeth Taylor, 1987
Silkscreen on acrylic gesso on canvas
2 paintings, each 152.5 x 122cm
Collection of The Estate of
Tony Arefin, London

Time Piece, 2005
35mm film, 1 min.
Director: Sharon Summers
Director of Photography:
Kenneth C.Dodds
Camera Assistant:
Richard Lawson
Sound: Peter Groom
Grading: Mark Lediard
Runner: Jon Bewley
Post Production: Transmission,
Newcastle-upon-Tyne.
Commissioned by The
Fruitmarket Gallery, Edinburgh
and Ikon Gallery, Birmingham

IKON GALLERY

Color Match, 1997
Audio CD, 12 min 40 secs.
Edition of 50
Dimensions variable
Courtesy the artist and
Lisson Gallery, London

Framework for Colour Co-ordinating and Building Purposes, (House of Windsor), 1992
Framework for Colour Co-ordinating and Building Purposes, (House of Stuart), 1992
(with Douglas Gordon).
Five litre paint cans
Dimensions variable
Courtesy the artist and
Lisson Gallery, London

I Quattro Formaggi II, 1992
Ceramic Tiles
310 x 415.5cm
Courtesy Lisson Gallery, London

J.P. 233 in C.S.O. Blue, 1992
Wall drawing
Dimensions variable
Collection of Tate Gallery,
Gift of Contemporary Art
Society, London

The Last Supper arranged according to the Flat Back Four Formation (Jesus Christ in Goal), 1990
Wall drawing
Dimensions variable
Collection of Patricia Bickers,
London

Le Match des couleurs, 2000
DVD projection and website
commission for Tate online,
9 mins.
Dimensions variable
Courtesy Lisson Gallery, London

Babylon, 2005
Digital wallpaper
Dimensions variable
Commissioned by Ikon Gallery,
Birmingham

Untitled, 1990
Wall drawing
Dimensions variable
Collection of Jack and Nell
Wendler, London

Untitled (Sails), 1996
Three parts: steel, aluminium,
Dacron and mixed media
Each 550 x 400 x 200cm
Courtesy the artist and
Lisson Gallery, London

SITE SPECIFIC PROJECTS

Landskip, 2000/05
Military smoke grenades
Presented at Winterbourne
Botanic Gardens, University of
Birmingham and Calton Hill,
Edinburgh 2005
Originally commissioned by
Compton Verney Trust, curated
by Locus+, 2000

Manned Flight, 1999–
Installation, Edinburgh

Roadworks, 1993/2005
Road paint, flags
Installed at Millennium Point,
Eastside, Birmingham, 2005
Originally installed at Route
Nationale 86, Givors, France,
1993